NEVELSON
WOOD SCULPTURES

D 367 A Dutton Paperback $4.00 In Canada $4.75

This book surveys the stylistic evolution of Louise Nevelson's wood sculpture over three decades, focusing on the primal themes so identified with her art — "table landscapes," columns, boxes, reliefs and walls. More than sixty works are illustrated, ranging from small-scale containers (the "Cryptics") to a sequence of monumental black walls that she has continued to produce since the mid-1950s. In addition, a number of recent photographs of Nevelson in her studio are included.

Wood is indisputably Nevelson's medium and the exhibition documents her remarkable use of this material. Although she has recently made small, precise plexiglass cube constructions and overseen the translation of several of her earlier wood pieces into large cor-ten steel sculptures, the genesis and essence of her art is in her special use of wood, with which she creates seemingly weightless shapes whose iconography relates them to the past as well as to the present. She is an accumulator, a compulsive forager of abandoned and discarded fragments — chair backs, architectural scrollwork, brush handles, weathered planking, and sweepings of chips and slivers from the carpenter's floor. These become the ingredients of her spectral, architectural compositions which, painted a uniform color — black, white or, on rare occasions, gold — allude to a mysterious reality.

NEVELSON
WOOD SCULPTURES

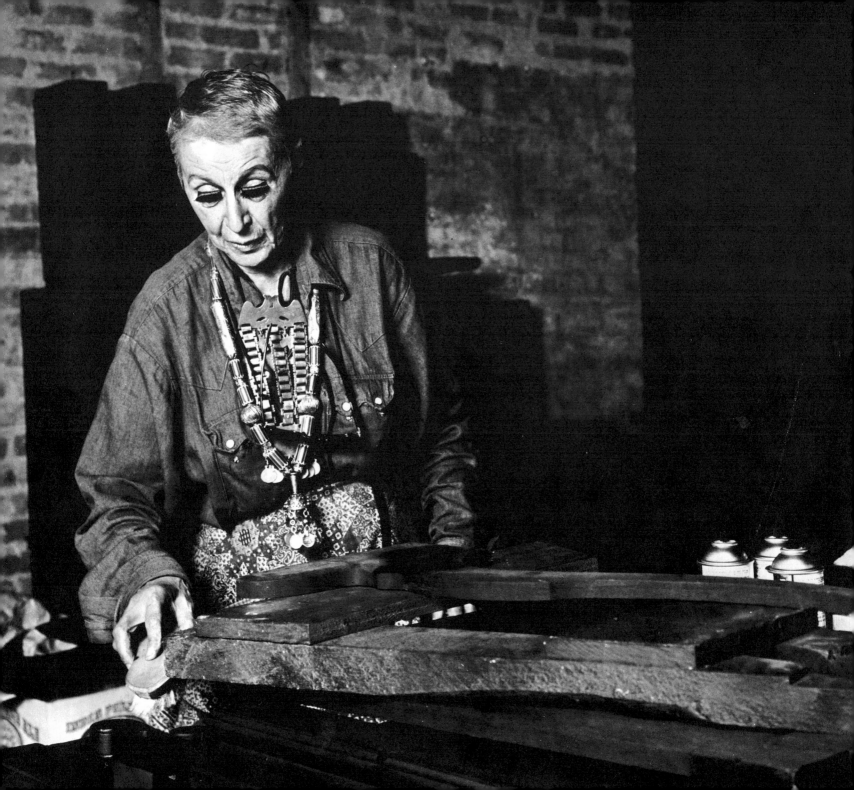

NEVELSON
WOOD SCULPTURES

by Martin Friedman

E. P. Dutton & Co., Inc., New York, 1973

an exhibition organized by Walker Art Center

Walker Art Center, Minneapolis
November 10 - December 30, 1973

San Francisco Museum of Art
January 25 - March 10, 1974

Dallas Museum of Fine Arts
April 17 - May 19, 1974

The High Museum of Art, Atlanta
July 6 - August 18, 1974

**William Rockhill Nelson Gallery of Art,
Kansas City, Missouri**
September 21 - November 3, 1974

The Cleveland Museum of Art
January 28 - March 9, 1975

Copyright © 1973 Walker Art Center

All rights reserved. Printed in U.S.A.

First edition

No part of this book may be reproduced
in any form whatsoever without permission
in writing from the publisher, except by
a reviewer who wishes to quote brief
passages in connection with a review written
for inclusion in a magazine or newspaper
or broadcast.

Published simultaneously in Canada by Clarke,
Irwin & Company Limited, Toronto and Vancouver.

Library of Congress Catalog Card No. 73-89272

ISBN 0-525-47367-X

Lenders to the Exhibition

Mr. and Mrs. Douglas Auchincloss, New York
S. R. Beckerman, New York
The Brooklyn Museum, New York
Brown University, Providence, Rhode Island
Herbert S. Cannon, Tenafly, New Jersey
Dr. Barbaralee Diamonstein, New York
Mr. and Mrs. B. Dunkelman, Toronto
Mrs. Martin A. Fisher, New York
Arnold and Milly Glimcher, New York
Mr. and Mrs. Arthur A. Goldberg, New York
Mr. and Mrs. Donn Golden, Larchmont, New York
Dr. and Mrs. S. Elliott Harris, Pikesville, Maryland
Joseph H. Hirshhorn Collection, New York
Mrs. Joseph H. Hirshhorn, New York
Mr. and Mrs. Alexander Hollaender, Oak Ridge,
 Tennessee
Dr. John W. Horton, Houston, Texas
Mr. and Mrs. Paul M. Ingersoll, Bryn Mawr,
 Pennsylvania
Martha Jackson Gallery, Inc., New York
Olga H. Knoepke, New York
Dr. and Mrs. Leonard Leight, Glenview, Kentucky
Judd A. Lewis, New York
Howard and Jean Lipman, New York
Mr. and Mrs. M. A. Lipschultz, Chicago
Albert and Vera List Collection, Byram, Connecticut
Mr. and Mrs. H. Gates Lloyd, Haverford, Pennsylvania
Locksley/Shea Gallery, Minneapolis
Mrs. Vivian Merrin, New York
The Metropolitan Museum of Art, New York
Mr. and Mrs. Ben Mildwoff, New York
Mr. and Mrs. Myron A. Minskoff, New York
The Museum of Fine Arts, Houston
New York University Art Collection
The Pace Gallery, New York
The St. Louis Art Museum
Mr. and Mrs. Sidney Singer, Jr., Mamaroneck,
 New York
Mr. and Mrs. Louis Sosland, Kansas City, Missouri
Karen Jo Sperling, New York
Mr. and Mrs. Harold P. Starr, Philadelphia
Mr. and Mrs. Philip A. Straus, Larchmont, New York
Mrs. Doris Warner Vidor, New York
Walker Art Center, Minneapolis
Whitney Museum of American Art, New York

Acknowledgments

Louise Nevelson's enthusiasm for a large-scale presentation of her wood sculptures made this exhibition possible. Because her verbal images are as complex and expansive as the works which are so identifiably hers, the artist's lengthy interviews with members of the Art Center staff provided new insights into her philosophy and working procedures.

I am grateful to all of the many collectors, museums and galleries who have loaned their valued Nevelson sculptures for the duration of this exhibition's tour. Special thanks are due Arnold Glimcher, Director of The Pace Gallery, whose patient assistance during the organization of this exhibition was crucial to its completion. Mrs. Arnold Glimcher and Judith Harney assisted in arranging loans of the works for the exhibition. Mr. David Anderson of the Martha Jackson Gallery, which represented Mrs. Nevelson from 1959 to 1962, made available a large group of works.

Important documentation, incorporated into the Bibliography section of this catalogue, prepared by Mrs. Gwen Lerner, was provided by the Archives of American Art. Members of the Art Center's staff worked with me on the development of the show: Dean Swanson assisted in preparation of the catalogue and was in charge of arranging loans; Dean Swanson and Gwen Lerner conducted an interview with Mrs. Nevelson which provided the basis for the catalogue material and I continued discussions with her based on that interview; Gwen Lerner, with the assistance of Lynda Hartman, handled details of the loans; Mildred S. Friedman supervised preparation of the catalogue; James E. Johnson, with the assistance of Wayne Henrikson, designed the catalogue; Peter Georgas was responsible for public information; Joan Benson, Linda Erickson and Donna Gale provided secretarial assistance. Working with me on the installation of the exhibition at Walker Art Center were Richard Koshalek and Dean Swanson, with the assistance of Eldor Johnson, Stuart Nielsen, Terry Fisher, Douglas Caulk and Meridith Dotzenrod.

MF

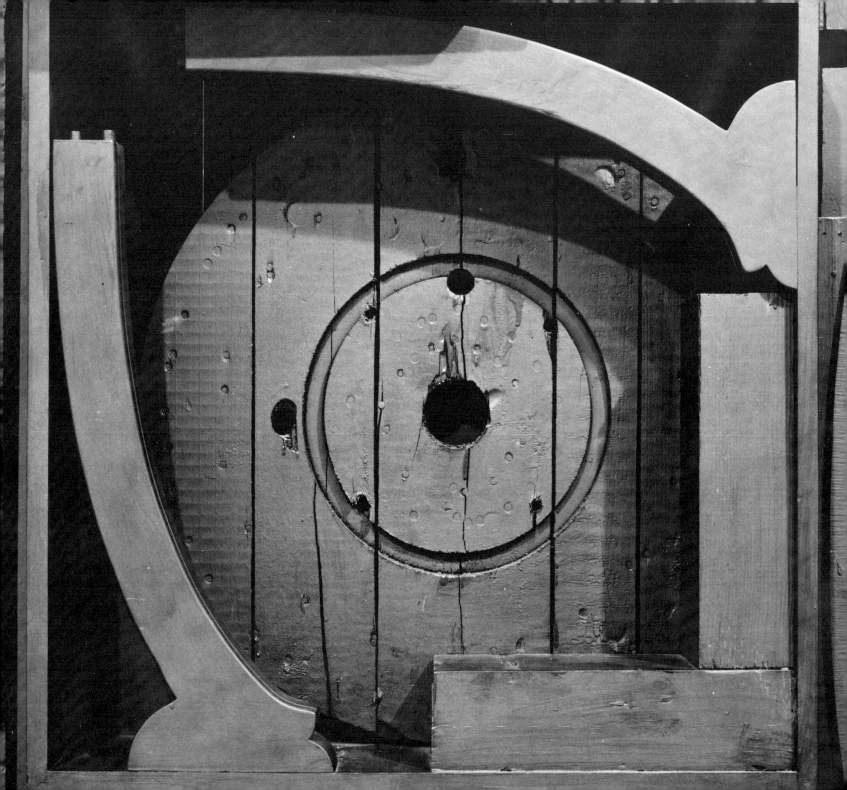

Nevelson: Wood Sculptures

by Martin Friedman

Nevelson's sculptures are phantom architecture. Installed against the walls of a room or standing free, they allude to no single time or place. They are structures about the *idea* of architecture and refer to no specific historical period, even though fragments of ornamentation evocative of Doric and Ionic columns, baroque carving and Victorian finials, are imbedded in their surfaces. Such quasi-historical clues, juxtaposed with bits of driftwood, coat hangers, cable spools, chair backs and other relics of daily existence, combine a fantasized past with an ambiguous present. While Nevelson has always been attracted to monumental antique art — primarily Meso-American architecture — the mystery and scale of those forms interest her more than their detail, function or symbolism. She focuses only on those aspects that reinforce her strong attitudes about shape and surface, and because a sense of invention colors her view of the past, her sculpture is in no sense "archeological." The observer, unable to mentally penetrate the facades of her sculptures, is bemused by the transmutation of once familiar objects into timeless structures.

In the early 1950s Nevelson's art reached the point where it became psychologically "closed" and self-contained. She began to repeat certain primal structural motifs — columns, walls, reliefs and boxes. Aside from their allusions to architecture, these forms also referred to the organic processes of growth and decay, and throughout Nevelson's earlier production the temporality of the natural and man-made world was a dominant theme. She was less interested in producing an art of "finish" than in revealing inexorable evolutionary process. Working within the now venerable tradition of assemblage, she divested familiar objects of their original identity, absorbing them as elements within her complex, cellular structures.

The architectural analogy persists, and while she rarely creates works that suggest complete buildings, her walls and towers seem to have been parts of larger structures. But if such enigmatic shapes inevitably suggest the antique and the dream world, it is the living city's forms that give meaning to her art. Her early wooden sculptures were made of packing crates and broken and abandoned pieces of architectural ornamentation foraged from the streets and loading docks near her studio. A relentless hoarder, she filled her working spaces with boxes of "found" treasures; with these ingredients, she hammered and glued together shapes that reflected the city's erratic modular configurations. The psychic and aesthetic core of Nevelson's art remains urban. She rarely leaves her Spring Street house and studio for any extended time and works there, surrounded by the battered, irregular geometry of downtown New York.

If Nevelson's sculpture evokes the city's forms, it does not suggest its kinetic quality. Within it a spiritualized geometry prevails; free of urgency, her art is expressive of fragile metamorphosis, not monumentalism. She regards herself as "an architect of shadows" and ponders the city's transformation at night, when solids and voids become interchangeable, and familiar objects lose their contours in shadows and reflections. Derived from such attitudes, her sculpture is wholly atmospheric. Spectral shapes dominate their spaces and under the dim lighting she prefers, her somber black volumes dissolve into complex surfaces. The sculptures are deepened picture planes and box-like, shallow spaces filled with low relief arrangements. Because of their frontality, static quality, apparent weightlessness and Nevelson's obsession with surface, these tenuous shapes can best be considered within the context of illusionistic painting rather than in the terms of conventional sculpture.

Nevelson began her painting studies at the Art Students League in 1928, and in 1931 briefly attended Hans Hofmann's Munich atelier. Under the WPA artists program in 1932, she assisted Diego Rivera with several mural projects in New York but considered this episode to be artistically inconclusive for her, and her interest soon shifted to sculpture. Progress towards her well-known style included an important formative period from the early 1930s through the mid-1940s, when she produced a great number of small-scale, abstract works based on

human and animal themes in marble, stone and cast metal — but mainly in terra-cotta and "tatti-stone," a self-hardening material. These compact pieces are a virtual index of the prevailing influences of Cubism and Surrealism, and also reflect her interest in African and Pre-Columbian sculpture and early American farm tools (she was a dedicated collector of such objects). Like many New York artists then seeking alternatives to regional pictorialism, Nevelson borrowed the reductive, abstract shapes of Picasso, Arp and Miro, and her sculpture of the 1940s oscillated between planar, cubistic shapes and organic volumes.

For almost fifteen years her work was part of a widespread vernacular of abstraction that provided the basis for the great breakthrough which began in the 1940s and ultimately shifted the center of international art to New York. Nevelson was increasingly dissatisfied with the use of traditional materials and techniques to achieve new form. She had little respect for the sanctity of bronze and marble and to liberate herself from heavy cubist shapes, she started to work with wood in the early 1940s. At the Norlyst Gallery, in 1943, she showed *The Circus*, a large-scale environmental work consisting of a number of geometricized clown and animal shapes formed of roughly cut boards, crudely nailed together. While her friendships were generally stronger with American painters than with sculptors, this collection of works, especially in theme and approach, was reminiscent of Calder's well-known circus sculptures; Nevelson's rough planking, however, had none of the suave linear character of Calder's objects.

Among Nevelson's sculptor friends was David Smith, whose welded abstractions she admired, and she sought an open form in wood comparable to that of Smith's metal pieces. Paradoxically, at a time when many advanced American sculptors were working with direct welding, a process she had no desire to master, she made wood her exclusive medium. Wood was readily available and easily worked. She liked its character, in its natural or refined state, and adapted it easily to her intuitive working methods. While some of the early wood figurative pieces were polychromed, she soon began to paint her sculptures entirely black to unify the disparate shapes within a composition and focus attention on the overall form of the work.

Unlike a number of artists who romanticized wood during this period, staining and polishing it to reveal the patterns of its grain, Nevelson quickly reduced it to an anonymous material. By painting the various elements of her wood sculptures a single color, she brought them all to the same level of reality. (While she still prefers to work in black because of its "weightlessness," she has produced an important group of white sculptures and a small series in gold.)

Nevelson's sculpture in the late 1940s proceeded from the same forces then shaping the new American painting. Some artists translated Cubism into a useful methodology of geometric abstraction and developed a reductive visual process through which the traditional subjects of figure, still life and landscape became radically simplified shapes. In painting, the results were sequences of overlapping planes of posteresque color that still preserved an identifiable subject. In sculpture, a comparable abstracting process occurred, resulting in "cubized" volumes. Although the grid system, implicit in Nevelson's sculpture, persistently suggests cubist affinities — particularly with the constructivist movement it generated — the modular character of the sculpture results more from her intuitive working process than from a reasoned approach. Her art is a species of "instinctive" Cubism, considerably filtered through other experiences.

Nevelson's early works reveal an interest in the anti-rational imagery of the Dada artists and in the sleek, organic forms of the Surrealists. Exiled from Europe during World War II, such luminaries as Arp, Ernst and Matta lived and worked in New York, where they preserved their own aesthetic atmosphere; relatively little contact occurred between them and the young American artists who, for the most part, remained on the outside looking in. But largely because of the presence of the emigres, such young American painters as Rothko, Gottlieb and Baziotes began their investigations of mythological and dream world subject matter. But the Americans' approach was not literal and in place of the European Surrealists' "hand-painted dream," the Americans evolved a pictographic style in which the canvas was divided into roughly defined grids in which floated rebus-like images of figures, primitive masks, astral shapes,

circles, arrows and asterisks — juxtaposed symbols that were intended to lead the observer into sequences of visual and psychological free associations.

A somewhat parallel evolution of form occurred in Nevelson's sculpture. The objects in her wooden "landscapes" of the 1940s, table-top arrangements of "found" objects, suggested the elementary imagery of the painters' pictographs. In these pieces, ambiguous relationships were generated between familiar and abstract objects and the resulting imagery evoked a variety of interpretations. Placing some of these configurations in deep-space boxes consisting of salvaged wooden crates, she began to conceive of them as frontal arrangements. Stacking these crates upon one another to form large cellular walls, she next created three-dimensional variations of the painters' pictographic grids.

The diverse, unrelated objects that compose Nevelson's formal vocabulary are selected for their shape, scale and texture, rather than for their original function. Parts of chairs and staircases, wheels, dowels, tubes and carpenters' laths are the neutralized components of larger configurations. On one level, their original identity persists, but Nevelson's eccentric combinations of them preclude rational comprehension of once familiar articles in their new contexts. They animate the surfaces of the sculptures without interfering with their basic outlines and an object's history is submerged in concise, disorienting arrangements. By painting the sculpture a single color, Nevelson divests familiar shapes of previous meanings and makes them "utilitarian and virginal." She "translates and retranslates" objects, and claims, "I'd be defeated right away if I had to remember that this is a leg from a chair...I'd be defeated immediately with that association."

By the mid-1950s the primal forms Nevelson generated were the basic elements of her sculpture. She constantly returns to and elaborates on these — the table-top "landscapes," the "columns," the closely related "reliefs" and "boxes," and the monumental "walls." These generic categories are intimately interrelated and, in many works, distinctions between them are blurred. These shapes first appeared in a series of large-scale environmental exhibitions, beginning in 1955 with *Ancient Games and Ancient Places,* a thematic presentation at the Grand Central Moderns Gallery. That show contained terra-cottas, stylized wooden figures with movable limbs, and notably, a group of wooden table-top "landscapes" formed of quasi-geometric blocks and wooden "found" objects. The "landscapes" were filled with vertical projections that suggested, variously, neolithic dolmens, tree trunks, towers and figures. It was through such small-scale environments that Nevelson began to plot her metaphysical architecture. She was positing environmental ideas that were to take dramatic form in a series of important exhibitions during the next few years. For example, the vertical elements in these miniature universes foreshadowed the columnar personages in *Royal Voyage,* her thematic exhibition at the Grand Central Moderns Gallery a year later. In this allegory of a mythological journey, a "king" and "queen" were symbolized by two over-life-size flat planks, notched and perforated with rectangular holes. (A purely stylistic simile for these pieces is African Dogon sculpture which also assimilates the human form within austere geometry.) Figurative associations still exist, if subliminally, in Nevelson's columns, a fact that she recognizes by designating them as "presences," "personages" and "totems."

Her exhibitions at the Grand Central Moderns Gallery consisted of a number of more or less completed pieces of various sizes which, during final installation, became components of ambitious thematic arrangements based on nature and mythology. To form these environments, Nevelson combined several works to make larger units, positioning individual sculptures to accommodate to the room's scale and architectural detail. Dissatisfied with the dense, unmodulated form of the conventional pedestal, she placed smaller works on wooden crates which, modified by the removal of their slatted backs and strengthened by the addition of triangular corner cleats, became integral elements of the sculpture. This procedure quickly led to the expansion of her ideas about form, and the crate soon became the distinctive Nevelson "box," whose interior was to be filled with extraordinary memorabilia. By 1958 Nevelson was piling "boxes" on each other in grid-like

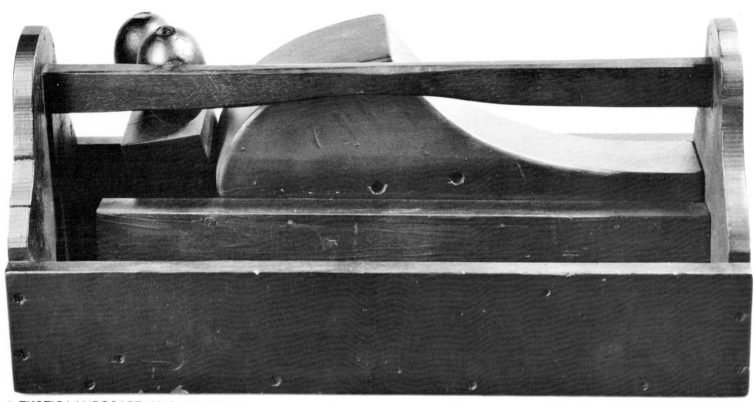

1 EXOTIC LANDSCAPE 1942-45 cat no 1
Courtesy The Pace Gallery, New York

arrangements, a process that inevitably led to the expansive "walls." That year at the Grand Central Moderns, she exhibited *Moon Garden Plus One,* a completely abstract environment, intended to be experienced under the most controlled lighting conditions. The spectral components of this grotto-like arrangement were attenuated columns encrusted with runic detail and low relief table-tops on squat bases. To unify these disparate forms and heighten the mystery of the space, windows were covered and two walls of the room were painted black. Initially, Nevelson intended to rely on the barely perceptible reflected light from spaces adjacent to the gallery; the results were almost total darkness and she was prevailed upon to light her pieces with a few blue light bulbs — a method of illumination she still likes. This exhibition, a watershed in the assertion of her style, contained her essential vocabulary of shapes, but in new variations. In this presentation, the "landscapes" had flattened into table "reliefs," and the "boxes" inspired a new group of tall, closet-like enclosures. Most significantly, this exhibition included SKY CATHEDRAL, a cluster of "boxes" and "columns" that formed her first major "wall," an instant anthology of her ideas about form, space and light.

Nevelson still makes pieces identified with each of these basic categories and the evolution of style within each of them is worth examination. The "landscapes" also suggest surrealistic interiors, especially the microcosmic constructions of Miro and Giacometti. Early prototypes for the "landscapes" were a number of outdoor pieces, roughly fabricated arrangements of tools, pipes, spikes, rods, wooden cylinders and blocks mounted on heavy, flat bases, made for the garden of her East 30th Street house in 1943. Simultaneously, Nevelson was shaping and fitting together wooden elements to make such refined pieces as EXOTIC LANDSCAPE, 1942 (fig. 1). This sculpture consists of a carpenter's tool kit, one of whose long slots is filled with a curved wooden fin and a cube surmounted by two spheres; following the logic of the title, the handle of the container suggests a horizon line, the fin a planar mountain, and the sphere a sun or moon. While the relationship of specific shapes within EXOTIC LANDSCAPE establishes a strong presence for the sculpture, the subject remains elusive. For example, Nevelson

claims that EXOTIC LANDSCAPE might just as correctly be read as a reclining figure (the fin a body, the sphere a head, etc.). "Only a few basic forms unify the art of all periods, the rest are variations," she says. "I build the appearance of a universe from parts of such forms." Her constructions are neither involved with specific meaning nor do they contain distinct, personal symbols; they function on many levels of association. Consequently, her art is about the distillation of experience, not description.

In the celebrated 1958 exhibition *Moon Garden Plus One,* the primal form of the "landscape" evolved into flat disks encrusted with complex layers of wood strips that functioned texturally rather than as separate projecting forms. Although Nevelson rarely returned to the clearly defined small processional "landscapes" of the 1950s, this idea persisted in larger pieces. At The Museum of Modern Art in 1959, she showed an ambitious environmental work, *Dawn's Wedding Feast,* which contained her first white sculpture — a large "wall," clusters of "columns" and several floor pieces that extended the "landscape" well into the room. (With such white works, she was now, for a time, an "architect of reflections.") A fine surviving element of this now dismantled work is DAWN'S WEDDING PILLOW (fig. 2), a stepped platform covered with strata of broken boards, chair stringers and flat wooden triangles and circles. Never one to abandon a strong formal idea, Nevelson has recently revived the horizontal "landscape" as an independent entity. The floor piece NIGHT GARDEN, 1973, is an excellent example, consisting of four equal triangular units fitted together to complete a square; its cellular structure also links this piece to the wall "reliefs." A new group of table-top works, "bridges," represents an impressive sub-category of the "landscapes" and their jumble of objects strongly recalls the earliest manifestations of this series.

Boxes and Reliefs

"Boxes" and "reliefs" are two distinct but closely related categories, each readily identifiable in its pure state. The "box," reflecting its crate origins, holds groups of salvaged and processed objects. Sometimes it is hinged to open at the top or front, or is perforated at the sides. By contrast, the "relief"

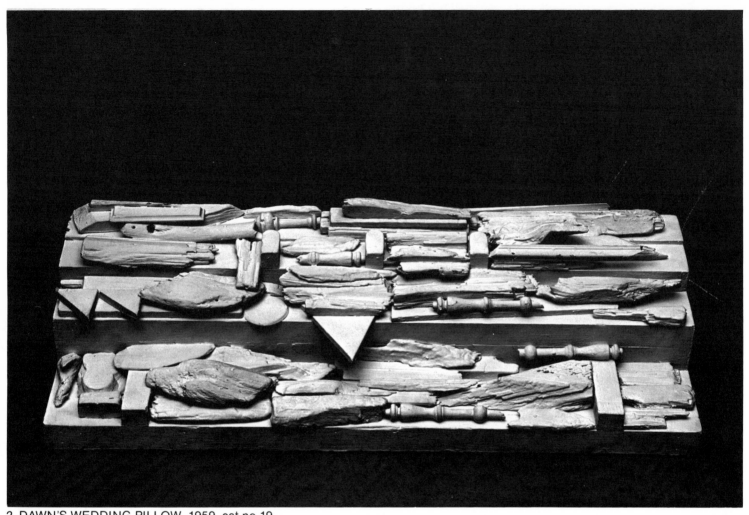

2 DAWN'S WEDDING PILLOW 1959 cat no 19
Collection Dr. John W. Horton, Houston

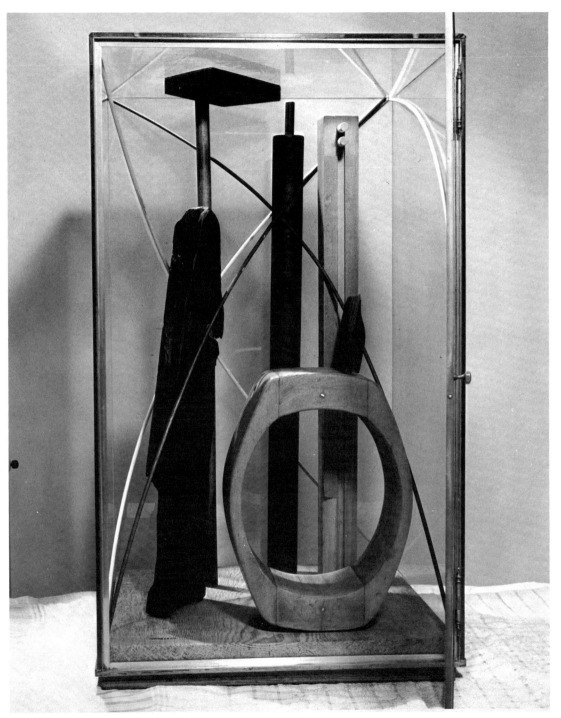

3 UNDERMARINE SCAPE 1956 cat no 7
Collection Mr. and Mrs. Ben Mildwoff, New York

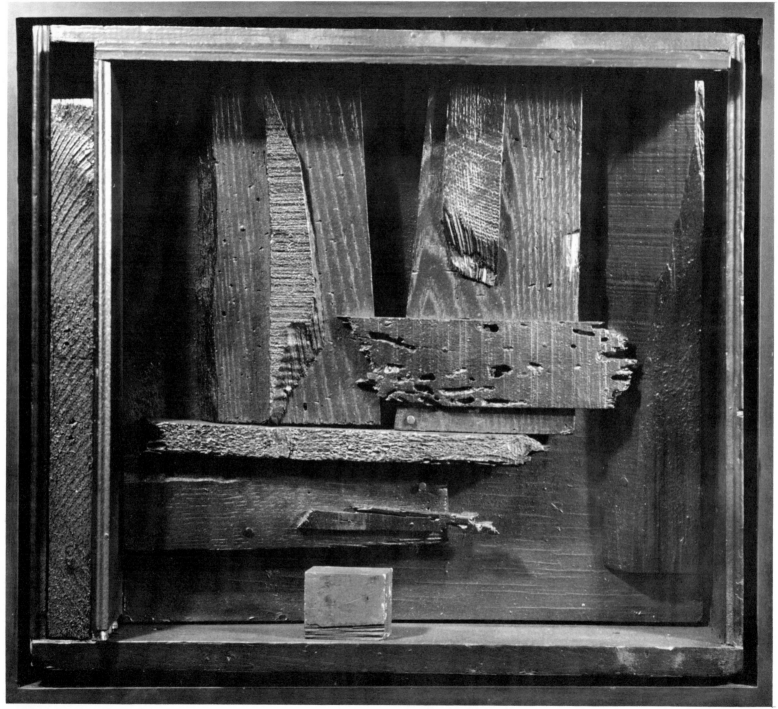

4 BOX NO. 1 1958 cat no 14
Courtesy Martha Jackson Gallery, Inc., New York

is a deepened picture surface, intended to be seen frontally against a wall. However, as it gains depth, the "relief" approaches the "box" and fine distinctions between the categories are impossible to make.

One of the earliest "boxes," UNDERMARINE SCAPE, 1956 (fig. 3), is a metal-edged glass cube enclosing a table landscape consisting of five major wood elements, with five bent wood dowels that are compressed against the edge of the case, forming arcs in the configuration.

A borderline case between "box" and "relief" is BOX NO. 1, 1958 (fig. 4). Crudely fashioned of crating, its four inch depth contains a sensitive arrangement of rough surfaced boards whose serrated edges suggest heavy impasto brushstrokes. For the exhibition *Dawn's Wedding Feast,* Nevelson made a number of complicated "boxes," one of the freest and most inventive being CASE WITH FIVE BALUSTERS (fig. 5). Bordered by a vertical row of half-cylinders and a line of lathe-turned stairposts, the central area of this "relief" contains a delicate arrangement of horizontal and vertical wood lathing, overlaid in the fashion of cubist brushstrokes. Because it is a flat horizontal work, CASE WITH FIVE BALUSTERS could just as well be discussed as a "relief."

About 1959, Nevelson began making "Cryptics" (figs. 6, 7), small "boxes" with lids whose surfaces were covered with flat disks, rectangles and geometric ornamentation — these "wonder-boxes" immediately precede the "Dream Houses," which represent yet another variation on the "box" — and also, to some extent, on the "column." In these exuberant structures, solid and void are thoroughly interrelated (fig. 8) and beneath the surface frenzy of jigsawed and cookie-cutter shapes are precisely constructed grids. In such works, Nevelson's cube, once the humble result of cast-off wood and primitive carpentry is now extravagantly enriched. The "Dream Houses" are visionary proposals for the house Nevelson never had. ("I've never lived in a place that I've really wanted to live in. It's always necessity. You wear what you can afford, you go to the dentist you can afford, you live in the place you can afford. Maybe I ought to live in the New York Library on Fifth Avenue. So this is what

I can do. I feel that we always make do under any circumstances. So I suppose I was searching for the house that I never had.") In spirit, the houses completely contrast with the unadorned spaces in which she lives and works. Recalling medieval reliquaries, they are dense, compact configurations in which panels open to reveal clusters of cubes and other block-like shapes; irregularly placed strips of picture molding suggest doors and windows, enliven surfaces and permit glimpses into strange interior spaces.

Nevelson's "reliefs" share the aesthetic of the table "landscapes:" objects are either adhered to flat planes or placed in shallow containers fastened to the wall. Many "reliefs" began as "landscapes" that found their way to "walls," and early ones from the mid-1950s — thick plank surfaces to which heavy cubes and half-cylinders are adhered — represent a species of robust Constructivism. RELIEF, 1956 (fig. 9), consists of three ponderous geometric forms against a thick wall plane; a cluster of circular volumes polarized around a vertical axis extends below the background panel. In this work, Nevelson's geometric abstraction is entirely improvisational, and the viewer is less conscious of measured interrelationships between elements than of surfaces varied by changing light and shadow.

When Nevelson began her association with The Pace Gallery in 1964, the "minimalist" aesthetic, with its dim view of expressionist excess and fortuitous effects, was beginning to dominate American sculpture. A fine, small relief, DIMINISHING REFLECTION XIII, 1965 (fig. 10), exemplifies her response to this new attitude. Such pieces, mounted on wide borders of wood and encased in plexiglass, represented a significant departure for Nevelson, who was now making "precious" objects. This elegance persists in a number of subsequent "reliefs," all virtually two-dimensional, and many of which utilize carefully finished planes of wood — triangles, circles — in rigid compositions. Such works illustrate some important side effects of Nevelson's visit to the Tamarind Lithography Workshop in Los Angeles where she quickly learned to adapt printmaking techniques to her needs. Since then, she has continued to utilize various printmaking

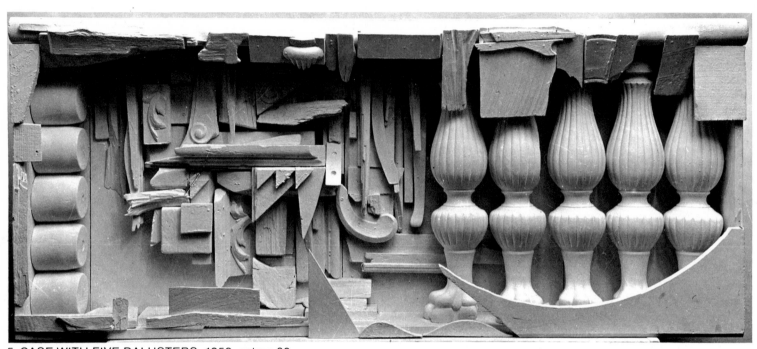

5 CASE WITH FIVE BALUSTERS 1959 cat no 23
Courtesy Martha Jackson Gallery, Inc., New York

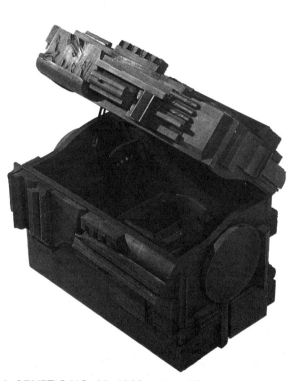

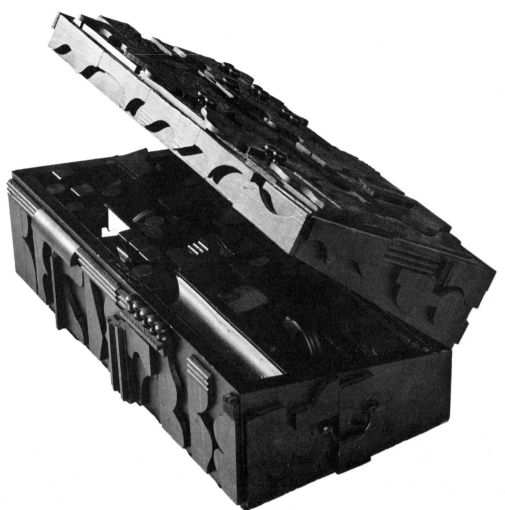

6 CRYPTIC NO. 63 1969 cat no 48
Collection Mr. and Mrs. Myron A. Minskoff,
New York

7 LARGE CRYPTIC I 1970 cat no 49
Collection Mrs. Martin A. Fisher, New York

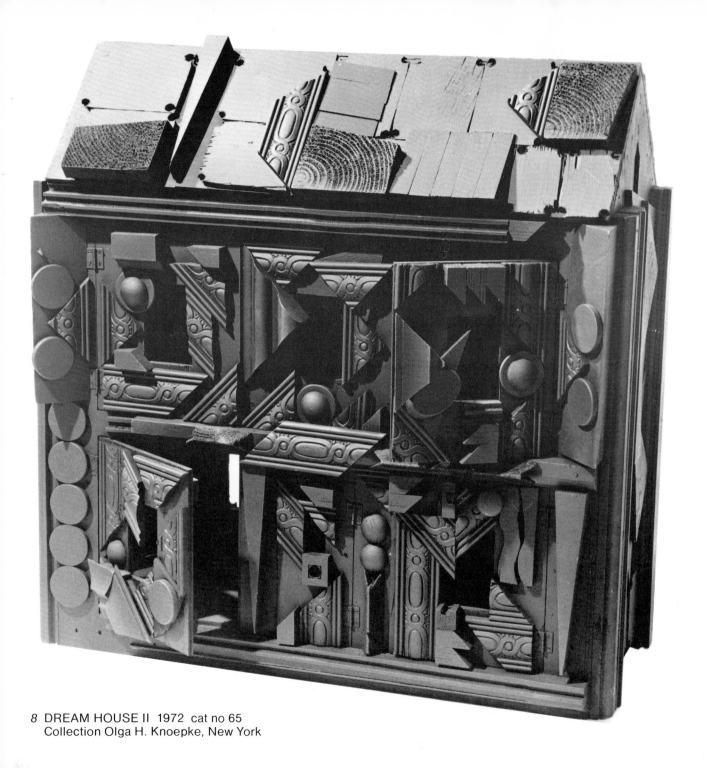

8 DREAM HOUSE II 1972 cat no 65
Collection Olga H. Knoepke, New York

9 RELIEF 1956 cat no 6
Collection Walker Art Center, gift of the artist

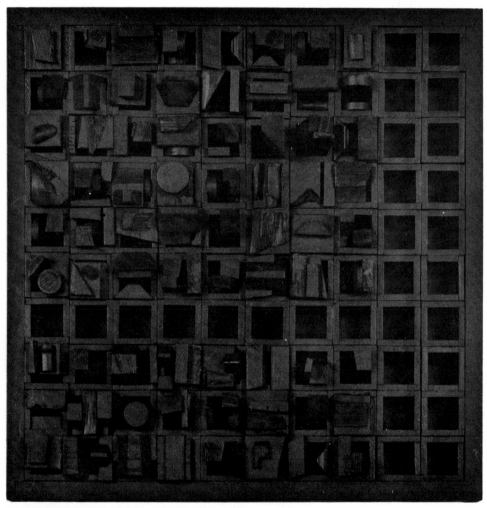

10 DIMINISHING REFLECTION XIII 1965 cat no 35
Collection Howard and Jean Lipman, New York

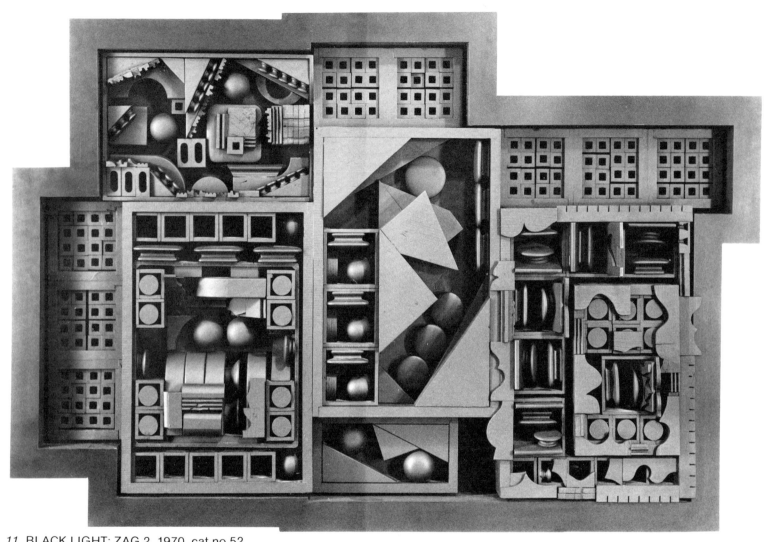

11 BLACK LIGHT: ZAG 2 1970 cat no 52
Collection Mr. and Mrs. Philip A. Straus, Larchmont, New York

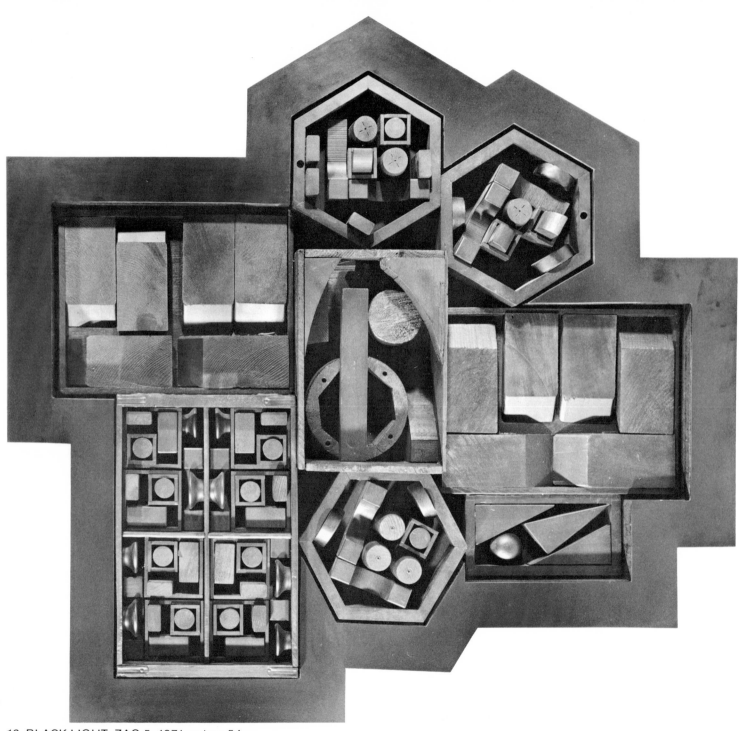

12 BLACK LIGHT: ZAG 5 1971 cat no 54
Collection Herbert S. Cannon, Tenafly, New Jersey

processes and, using flat wooden elements that also appear in her "reliefs," she developed a method of making embossed prints.

Since 1958 Nevelson has made "Zags," irregularly contoured black "reliefs" whose cells are impacted with small cubes, spheres and other precise shapes. Her clear break with the conventional "relief" format is apparent in these works, whose erratic contours result from the rectangular and hexagonal receptacles they enclose. Their outlines resemble the ragged perimeters of the early "walls" and are analogous to those of the "shaped canvas" paintings of the early 1960s — also dictated by internal shapes. Because of its non-rectangular format, the "Zag" can take a wide variety of forms. BLACK LIGHT: ZAG 2, 1970 (fig. 11), a bewildering accumulation of small components, looks like a cross-section of some improbable machine; by contrast, the components of BLACK LIGHT: ZAG 5, 1971 (fig. 12), are heavy sculptural shapes.

Nevelson's "reliefs" continue to grow more refined and recently she has utilized the fine grid of the typesetter's case for a series of pieces called "End of Day" (figs. 13, 14). These recall the complicated "reliefs" of the early 1960s and are an especially consistent group. Tiny faceted blocks, pyramids and spheres seem to ooze from the small cells of the typecase and crystallize in the air. Nevelson is unable to think of "reliefs" — or for that matter, of any of her primal shapes — as separate entities, and, lately, has combined groups of "End of Day" pieces to build new "walls."

Columns

Of all the primal forms Nevelson employs, the "columns" are the most anthropomorphic. Derived from an effort to unify small sculptures with their pedestals, the "columns" of the 1950s functioned abstractly as mythological figures in environmental works. The "columns" also relate to several large quasi-figurative pieces of the mid-1950s such as INDIAN CHIEF, 1955 (fig. 15) and FIRST PERSONAGE, 1956 (fig. 16); both are simple, planar shapes, the former about four feet high, the latter about eight feet. One edge of each piece

is embellished with a row of thin wooden wedges that suggest a mane, a feathered bonnet — even a series of ax blades. These tall, monolithic sculptures are antecedents of the columnar presences first seen as elements of Nevelson's early environmental exhibitions at the Grand Central Moderns and Martha Jackson galleries.

These "columns," whose projecting, spikey shapes simultaneously evoke towers, spires and tree trunks, are remarkable for their persistence in Nevelson's *oeuvre.* They bear such labels as NIGHT COLUMN, DAWN COLUMN and RAIN FOREST COLUMN. The "Rain Forest Columns" (figs. 17, 18), more articulated than their predecessors, consist of a sequence of boxes that twist along a common vertical axis. The "Young Trees" (figs. 19, 20) are recent, fine-scaled variations on "columns." They are constructed of sharply faceted cubes and, in contrast to the large "columns," have active, broken contours that extend horizontally.

Walls

Nevelson's "walls" began as the most dramatic elements of her thematic environmental exhibitions in the late 1950s. *Dawn's Wedding Feast,* 1959, her first white environment, featured a complicated "wall" consisting of numerous rectangular "boxes" and several small "columns" which Nevelson and an assistant turned into a monumental arrangement especially for the Museum of Modern Art's gallery space. Unfortunately, the components of the final piece, like those in her previous environmental exhibitions, were dispersed after the show. A few were reincarnated as new sculptures and one of the best, DAWN'S WEDDING CHAPEL II (fig. 21), a somewhat smaller distillation of the larger work, is in every sense a new and complete piece.

The "walls" are expansive cellular structures varying from six to 18 feet in width and averaging about nine feet in height; these dimensions are by no means exact — it is especially difficult to discuss the width of many of her large works because their sections can be arranged either in stepped or arced configurations. Since the first thematic shows, Nevelson has made "walls" as separate projects and an examination of

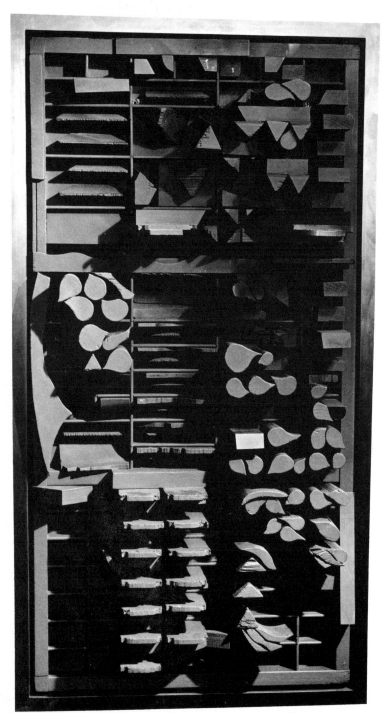

13 END OF DAY X 1972 cat no 75
Collection Dr. Barbaralee Diamonstein, New York

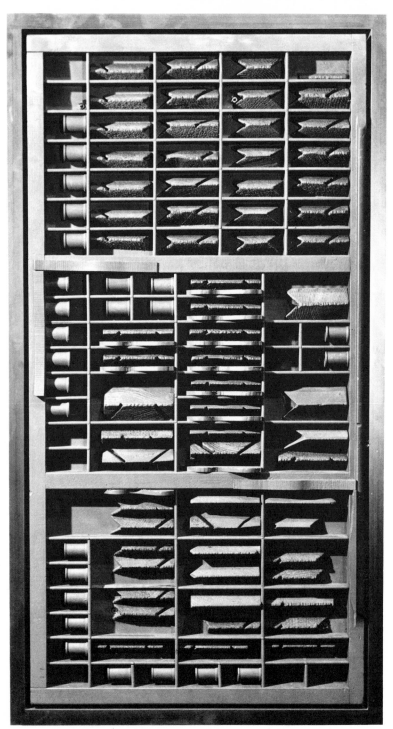

14 END OF DAY XI 1972 cat no 76
Collection Mr. and Mrs. Donn Golden, Larchmont, New York

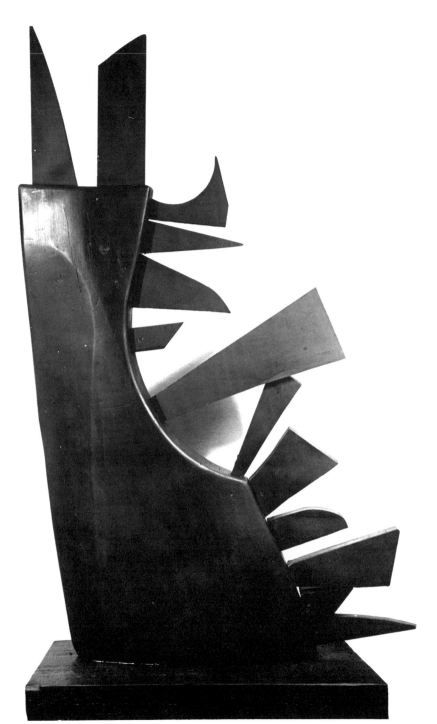

15 INDIAN CHIEF 1955 cat no 4
Courtesy Martha Jackson Gallery, Inc., New York

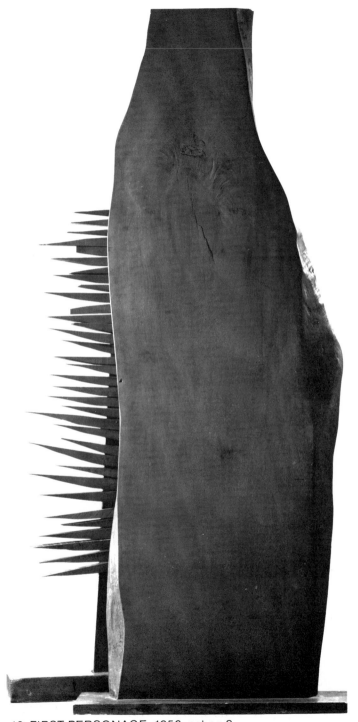

16 FIRST PERSONAGE 1956 cat no 8
Collection The Brooklyn Museum, New York,
gift of Mr. and Mrs. Nathan Berliawsky

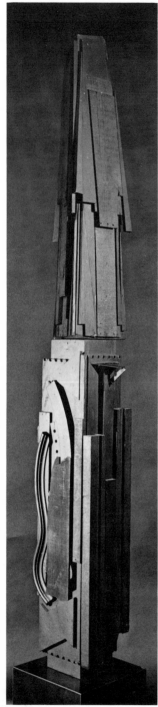

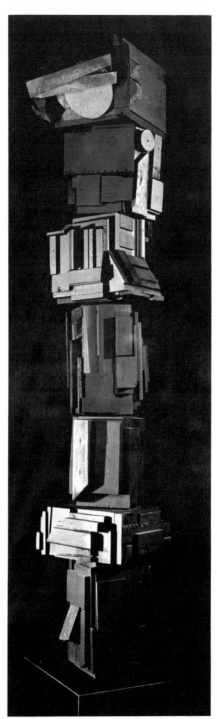

17 RAIN FOREST COLUMN XVII 1964-67 cat no 37
Courtesy The Pace Gallery, New York

18 RAIN FOREST COLUMN XXV 1967 cat no 40
Courtesy The Pace Gallery, New York

17

18

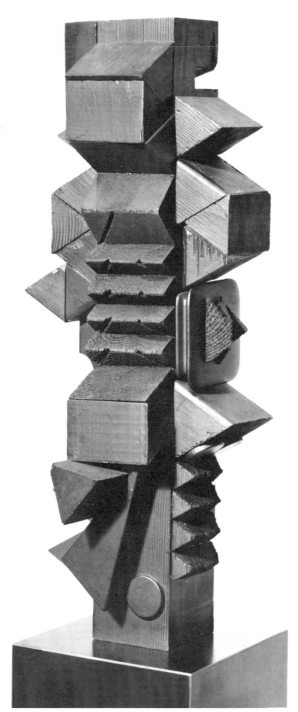

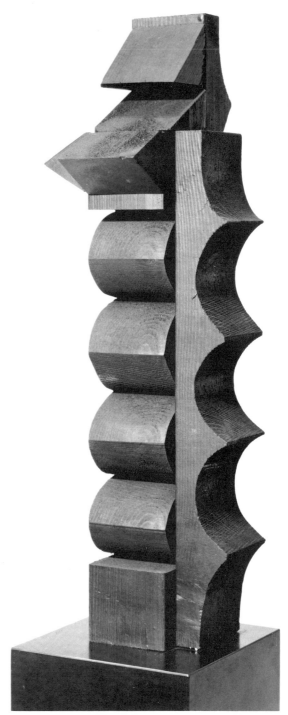

19 YOUNG TREE VI 1971 cat no 60
Collection Walker Art Center, gift of the artist

20 YOUNG TREE XIX 1971 cat no 61
Collection Walker Art Center, gift of the artist

27

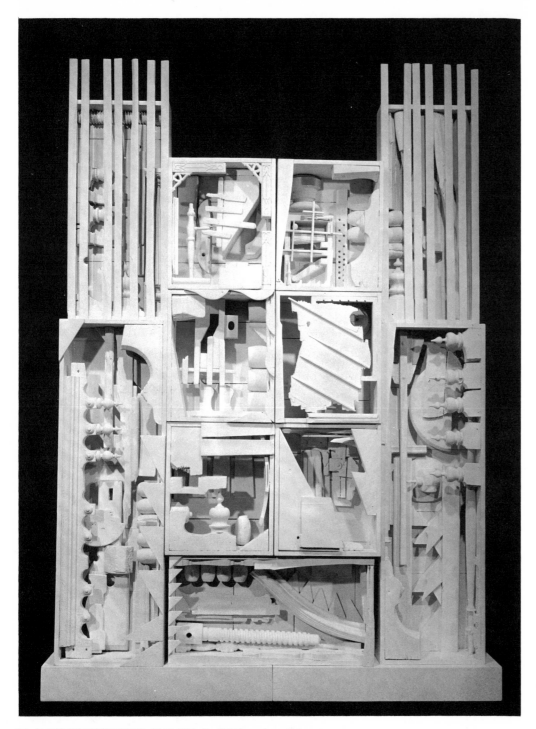

21 DAWN'S WEDDING CHAPEL II 1959 cat no 24
Collection Whitney Museum of American Art, New York,
gift of The Howard and Jean Lipman Foundation, Inc.

four included in this exhibition is an excellent means of tracing the stylistic range of her sculpture.

SKY CATHEDRAL PRESENCE (fig. 22), begun in 1951 and modified in 1964, exemplifies Nevelson's free-wheeling assemblage style. It consists of "columns" and "boxes" of various dimensions containing pieces of rough and sanded wood, tree limbs, architectural ornamentation and irregularly-edged planks — all anonymous objects nailed and fitted together. The weathered elements crammed into the "boxes" of SKY CATHEDRAL PRESENCE implicitly suggest the passage of time. This wall is an accumulation of forms and ideas that span several years; each box has its own history and the wall is a compendium of formal approaches, unified into one great rambling shape. Tall, thin doors open to reveal rich, enigmatic detail. No two "boxes" are the same size and each contains a unique arrangement. The wall is also a vast, ghostly cabinet whose compartments are filled with magic objects. Roughly symmetrical and highest at the center, SKY CATHEDRAL PRESENCE suggests an altar, an impression that results from its murky indefinite forms. Nevelson is conscious of the spiritual effect of her art on some but says her sculpture is "not a religious thing" — she intends it to be "images of feelings" and any religious associations are read into it by the viewer. (An austere variation on this composition is the large gold work, AN AMERICAN TRIBUTE TO THE BRITISH PEOPLE, 1960-65, in the Tate Gallery collection. Its components are a high column before a symmetrical wall whose side elements partially enclose the observer.)

NEW CONTINENT, 1962 (fig. 23), epitomizes a nervous dualism in Nevelson's art — an improvisational attitude about object shape and placement, and a strict one about overall format. Such tension between the intuitive and the measured habitually imparts psychic energy to her forms. NEW CONTINENT is a precisely fabricated grid filled with white painted jigsaw-cut elements, flat scrolls, rods and balusters. Planes resembling an architect's "French curves" serve as corner baffles and appear at various depths within the boxes. Because so many layers of activity occur within each unit, no single shape dominates, and individual forms are subordinated to the kinetic surface. Unlike SKY CATHEDRAL PRESENCE, a collection of abandoned curiosa, NEW CONTINENT has no past.

Perhaps the most distinctive compositional feature of NEW CONTINENT is the equal distribution of units of activity over the length and width of the work — a departure from the altar-like, centralized composition of such pieces as SKY CATHEDRAL PRESENCE. NEW CONTINENT'S strict modular structure also implies that the piece is capable of infinite vertical or horizontal extension. In this respect, it reflects "anti-cubist" compositional attitudes similar to those found in the "progressions" of such younger minimalist artists as Don Judd, some of whose works consist of of units that can be repeated to accommodate the sculpture to a given space. (In painting, this attitude is seen in the large horizontal stripes of Kenneth Noland, whose unmodulated paint surfaces are not "closed" at the sides.) While Nevelson is philosophically and stylistically far removed from the minimalists' attitudes, she was alert to their ideas about reductive form, and her interest in pure geometry was strengthened by contact with such work. This was especially apparent in the mid-1960s, when she began working in steel and plexiglass. She sensed no particular mystique about such media; nor was she involved in the "art and technology" movement of the period but, inevitably, her work in these hard-edged media suggests the effects of minimalist art. In their precision, her small-scale, glittering plastic "boxes" and steel grid pieces seem light years away from the expressionistic wooden sculptures. Such hard materials, although foreign to Nevelson's mentality, offered new opportunities to utilize her great skills in selecting and combining forms. The effects of this mechanical interlude, absorbed into her overall approach, did not substantially influence the archetypal forms that identify her art and, although the supporting structures of her large wooden pieces are now fabricated by carpenters, and her work is increasingly "measured," its essential character remains intuitive.

During the 1960s, Nevelson made a number of wooden "walls" that did not rely on the addition of "columns," "boxes" or "reliefs" to complete a thematic environment. Generally, these "walls"

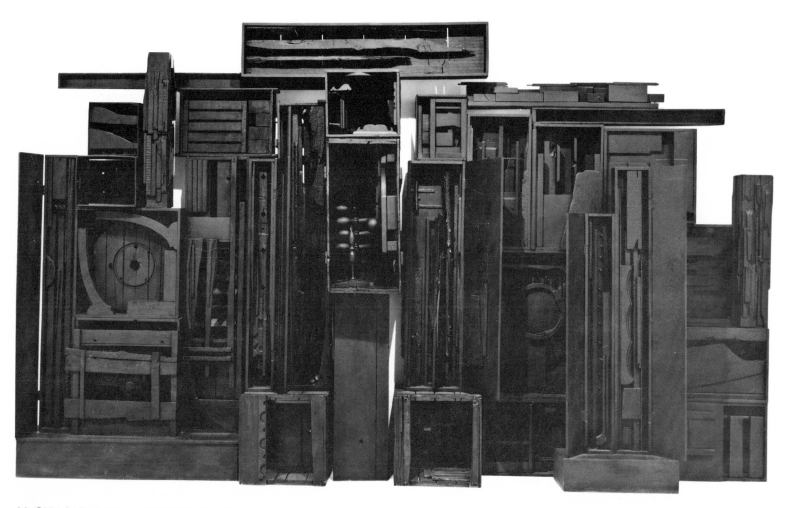

22 SKY CATHEDRAL PRESENCE 1951-64 cat no 30
Collection Walker Art Center, gift of Mr. and Mrs. Kenneth N. Dayton

are more mechanistic than their antecedents and reveal the experience of the factory-produced plastic and steel pieces. Early in her association with The Pace Gallery, she made a number of flat "reliefs" and and "walls." While some "walls," such as NEW CONTINENT, were a new departure for her in composition, Nevelson did not abandon her traditional formal configurations. The large black "wall," MIRROR IMAGE, 1969 (fig. 24), an impressive synthesis of her early approach to wall-building, uses "boxes" of various dimensions and indicates Nevelson's new interest in elementary, planar form. Its decisive contours allude to a mysterious alphabet of geometric cut-outs which, echoed by the voids in each "box," produce a shimmering chiaroscuro. In this "wall" Nevelson introduced a curious perspective, positioning its central element — a grid of large "boxes" — in front of symmetrical units consisting of smaller compartments. Such spatial ambiguity underlies many of her geometric sculptures, and she pursued such disorienting ideas in several "reliefs" and small "walls" which incorporate mirrored planes. CITY REFLECTIONS, 1971 (fig. 25), is an extreme example of Nevelson's simplifying process. This somber, irregularly contoured black "wall," whose major components are parallel slats of wood carefully fitted to the edge of each box, contrasts sharply with her intuitively conceived early "walls." Its title, and certainly its forms, suggests that its origins are in the faceless new architecture of New York. Paradoxically, in smaller scale works of the early 1970s such as the "Dream Houses" (fig. 26), she retains a relatively complicated and "painterly" surface.

Nevelson works on several projects simultaneously — "reliefs," "walls," large outdoor steel pieces and prints. For her sculptures, she prefers to work with whole elements, makes no sketches but develops ideas by combining pieces of wood or scraps of paper. Like an expert jigsaw puzzle solver, she instinctively finds the correct wooden elements as she forms a work. The development of each piece is a direct process that involves quick decisions to add or subtract, and then long periods of study. A work might remain unfinished for years, or simply be abandoned. She won't discuss a sculpture's evolution with objectivity and is impatient with questions about the techniques of fabricating her pieces. Methodology is of little interest to her and she is equally opaque on the subject of aesthetic theories.

While Nevelson's works are fabricated within grids or boxes, her geometry is strictly improvisational. On measurement: "Now, of course, a carpenter would never do what I do. I do everything against what they believe, but who cares? If my eye can't tell me what will fit or not, the hell with it." She believes that making art is a preordained role: "Look darling, I have a feeling that some people are born ready-made…so we don't add a great deal to ourselves. We unfold somehow. I haven't had a surprise in my life, whether good or bad! What can you surprise me with?"

"I take my experience of the past with me," she says, and considers that recently her art has assumed a wholly unified character. "I'm getting more harmonious with myself, more ordered in my being," she claims. One reason that her past and present work share such stylistic affinities is her practice of revising older pieces and borrowing complete elements from them for new constructions. This seems to her to be a perfectly natural practice since all pieces, in her view, are extensions of the same creative effort: "I have no interest in making masterpieces, no interest in perfection. I want to breathe *now*." She limits her materials and shapes and her overall production is entirely consistent. This is especially true of the sculptures in wood, Nevelson's favorite medium. She decided long ago that objects of aesthetic value could be made of any material: "It gave me great pleasure to think that I could take wood, make it good, and make people like Rockefeller buy it with paper money."

Nevelson's sculpture is about the revelation of daily existence. She is not a literary or historically minded person, nor is she interested in creating descriptive or symbolic forms. Her work is a distillation of impressions and experiences of life and embodies the forms and energies that surround us. In her art, these qualities are translated to an abstract level, with occasional clues in the form of recognizable objects, to a reality we all share.

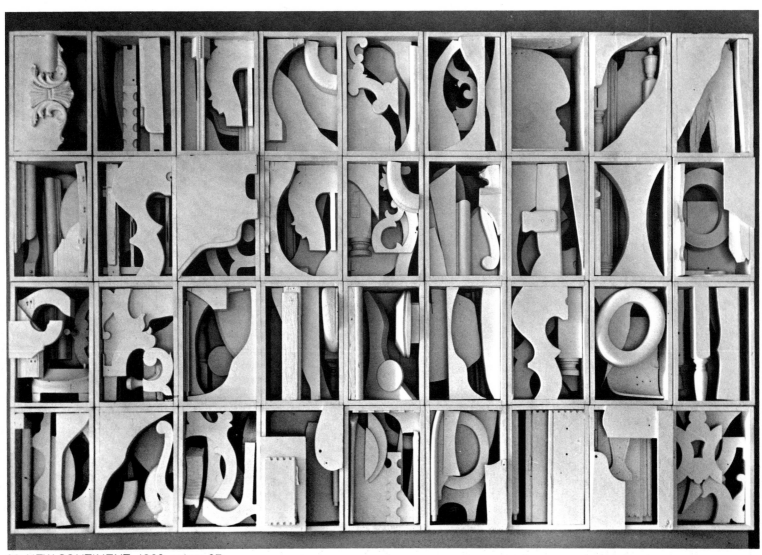

23 NEW CONTINENT 1962 cat no 27
Collection The St. Louis Art Museum

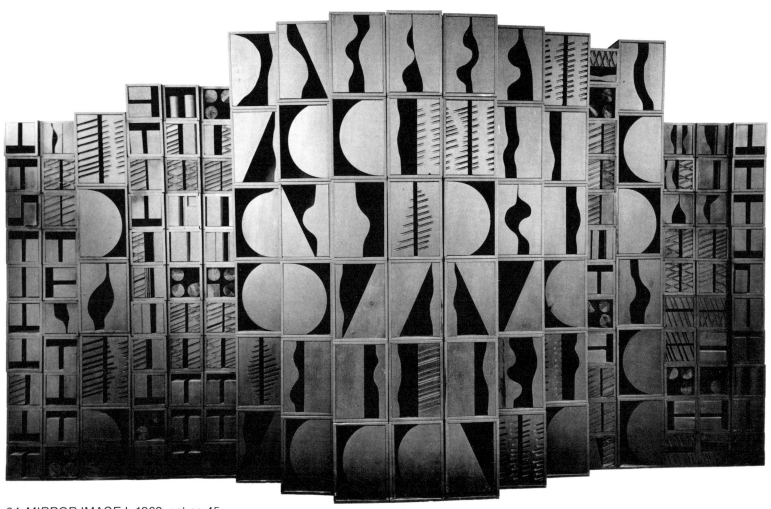

24 *MIRROR IMAGE I* 1969 cat no 45
Collection The Museum of Fine Arts, Houston, gift of The Brown Foundation

25 CITY REFLECTION 1972 cat no 64
Courtesy The Pace Gallery, New York

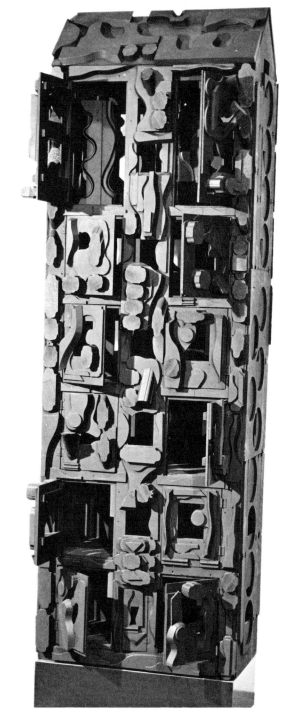

26 DREAM HOUSE XXXII 1972 cat no 68
Joseph H. Hirshhorn Collection, New York

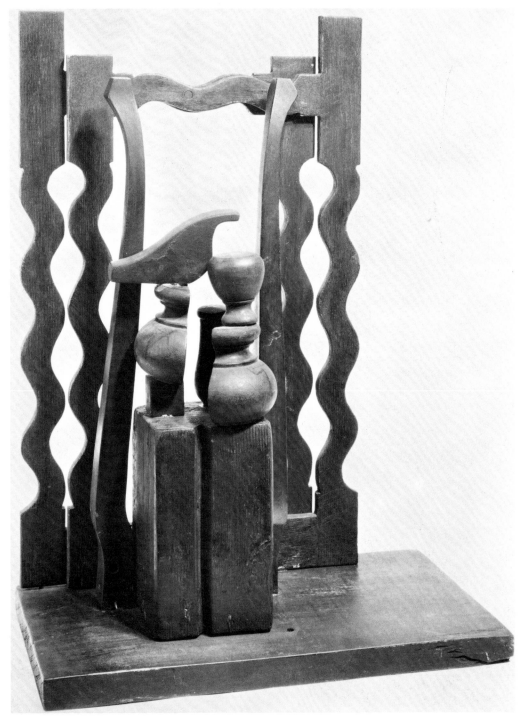

27 MODEL FOR NIGHT PRESENCE IV 1945 cat no 2
Courtesy The Pace Gallery, New York

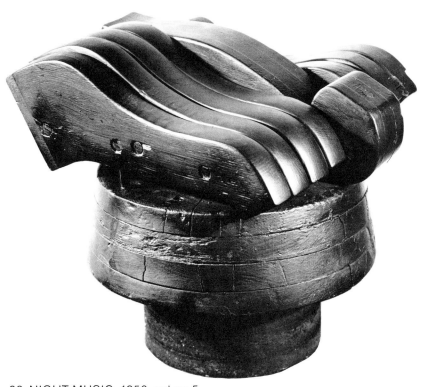

28 NIGHT MUSIC 1956 cat no 5
Courtesy Martha Jackson Gallery, Inc., New York

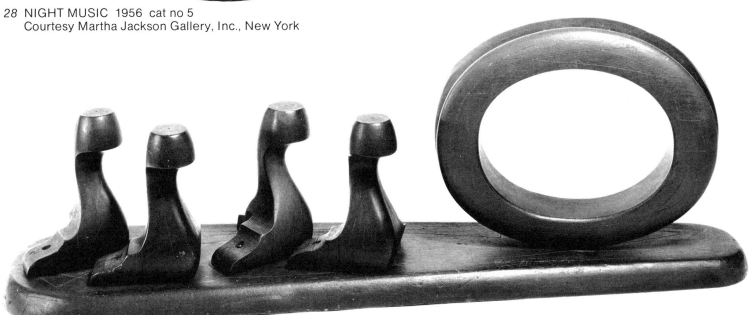

29 NIGHT PRESENCE VI 1955 cat no 3
Collection Mrs. Vivian Merrin, New York

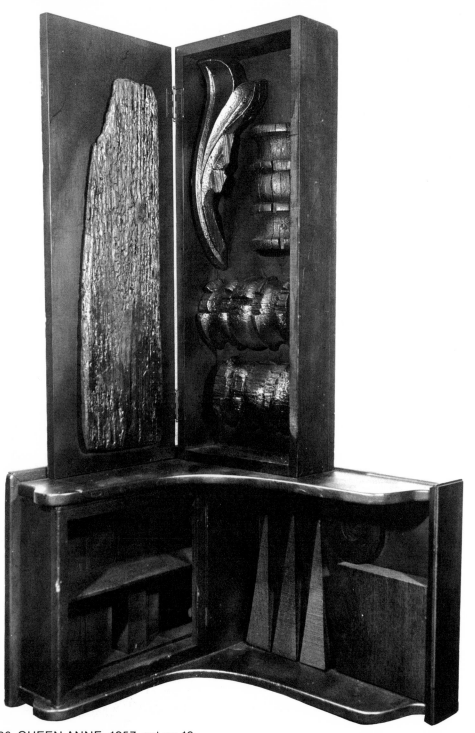

30 QUEEN ANNE 1957 cat no 10
Courtesy Martha Jackson Gallery, Inc., New York

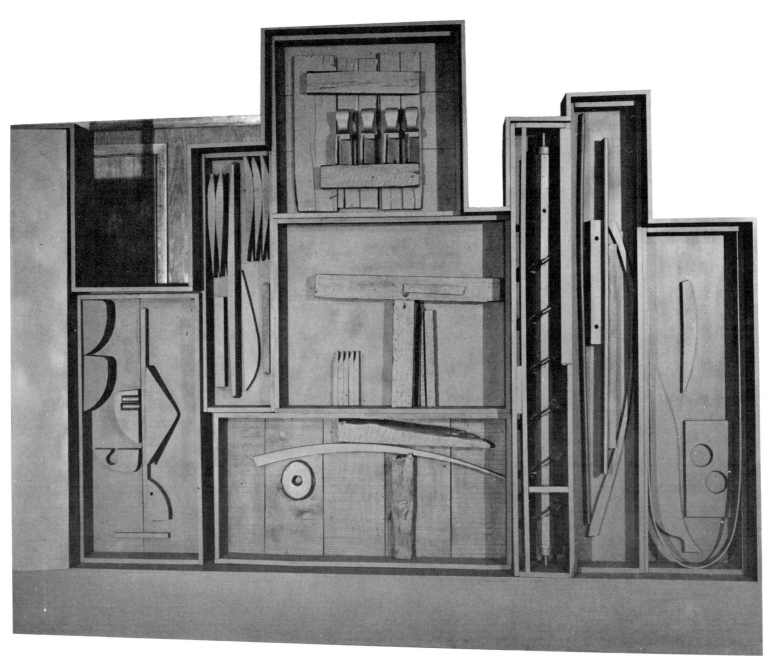

31 TROPICAL GARDEN I 1958-59 cat no 13
New York University Art Collection

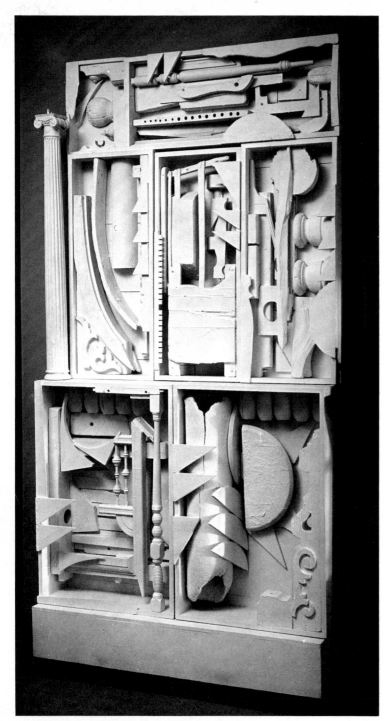

32 DAWN'S WEDDING CHAPEL I 1959 cat no 18 detail at right
Collection Dr. John W. Horton, Houston

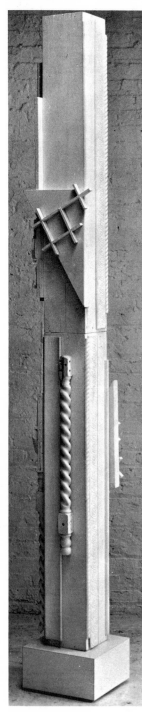

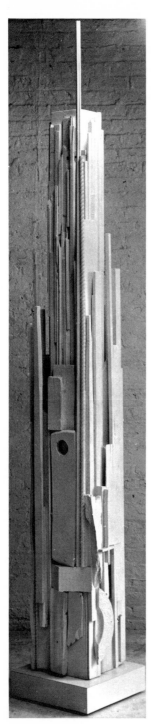

33 DAWN COLUMN I 1959 cat no 20
Courtesy Martha Jackson Gallery, Inc., New York

34 DAWN COLUMN II 1959 cat no 21
Courtesy Martha Jackson Gallery, Inc., New York

33

34

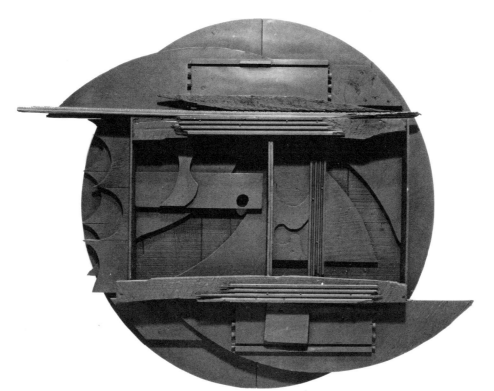

35 BLACK MOON II 1961 cat no 26
Courtesy Locksley/Shea Gallery, Minneapolis

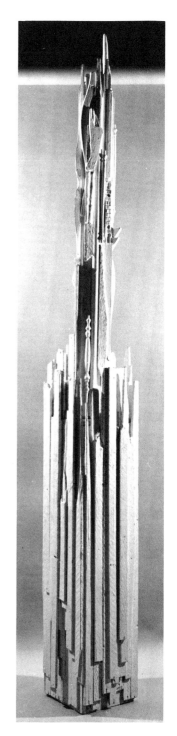

36 TOTEM II 1959 cat no 22
Courtesy Martha Jackson Gallery, Inc., New York

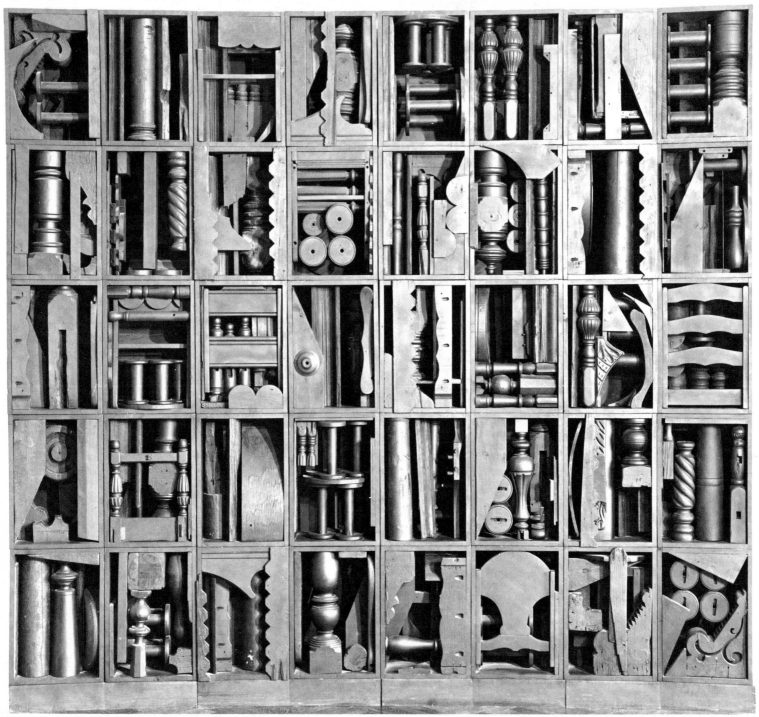

37 TIDE I TIDE 1963 cat no 28 detail at right
Albert and Vera List Collection, Byram, Connecticut

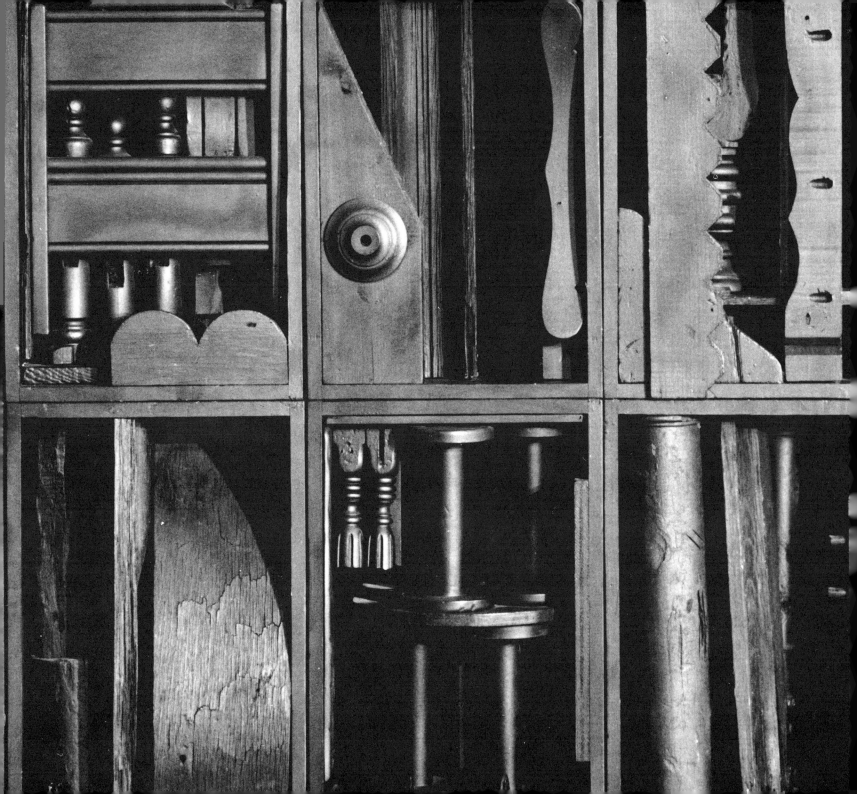

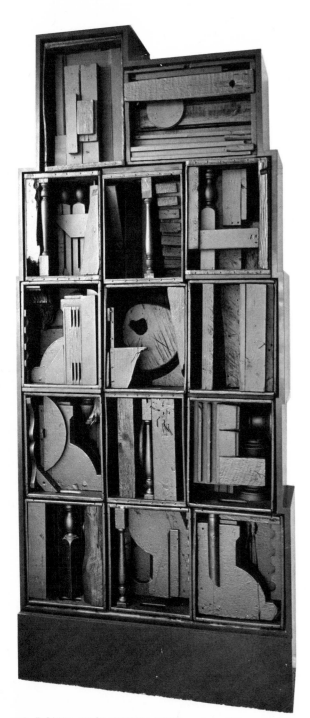

38 ROYAL NIGHTFIRE 1963 cat no 29
Collection Mr. and Mrs. Arthur A. Goldberg, New York

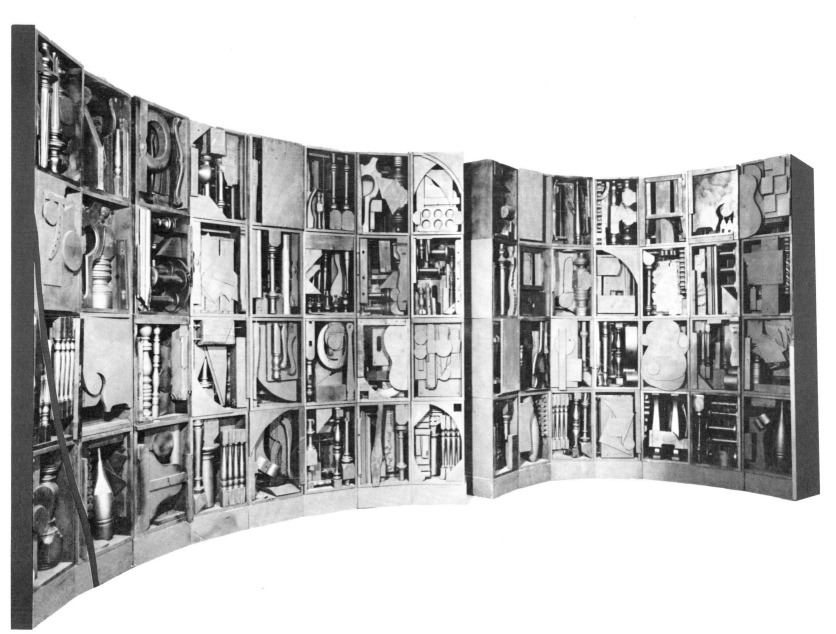

39 HOMAGE TO 6,000,000 I 1964 cat no 32
Collection Brown University, Providence, Rhode Island, gift of the Albert List Family Collection

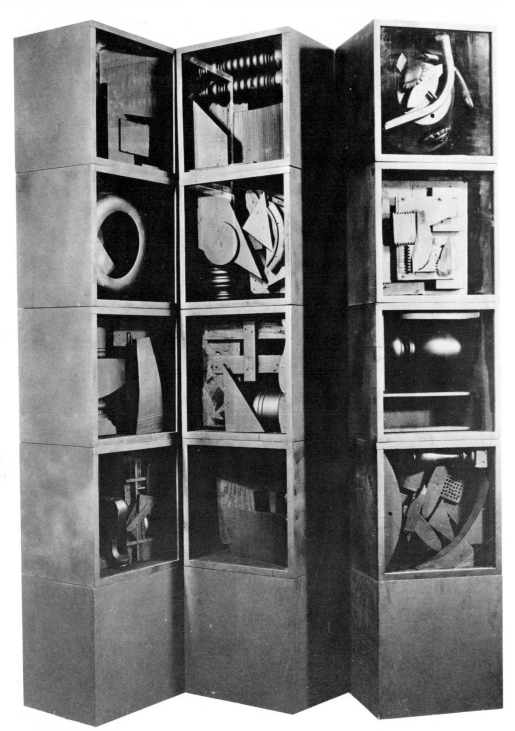

40 SILENT MUSIC VII 1964 cat no 33
Courtesy The Pace Gallery, New York

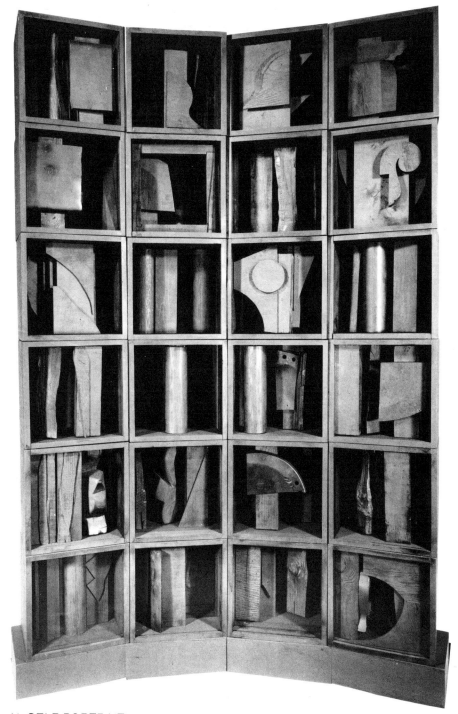

41 SELF-PORTRAIT 1964 cat no 34
Collection Mr. and Mrs. B. Dunkelman, Toronto

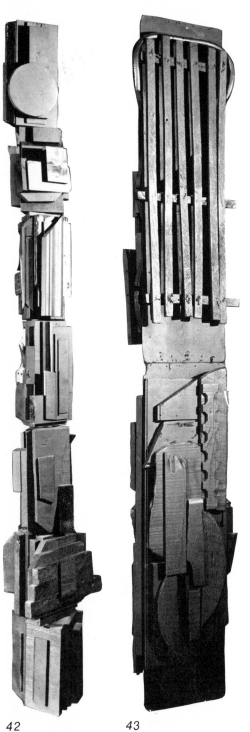

42 RAIN FOREST COLUMN XIII 1967 cat no 36
Courtesy The Pace Gallery, New York

43 RAIN FOREST COLUMN XX 1962-64 cat no 38
Courtesy The Pace Gallery, New York

44 RAIN FOREST COLUMN XXII 1964-67 cat no 39
Courtesy The Pace Gallery, New York

42 43 44

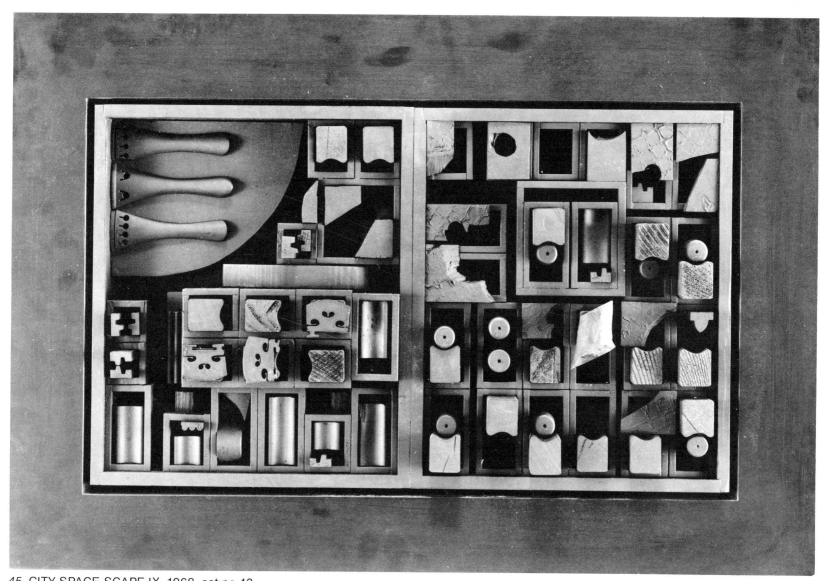

45 CITY-SPACE-SCAPE IX 1968 cat no 42
Collection Mrs. Doris Warner Vidor, New York

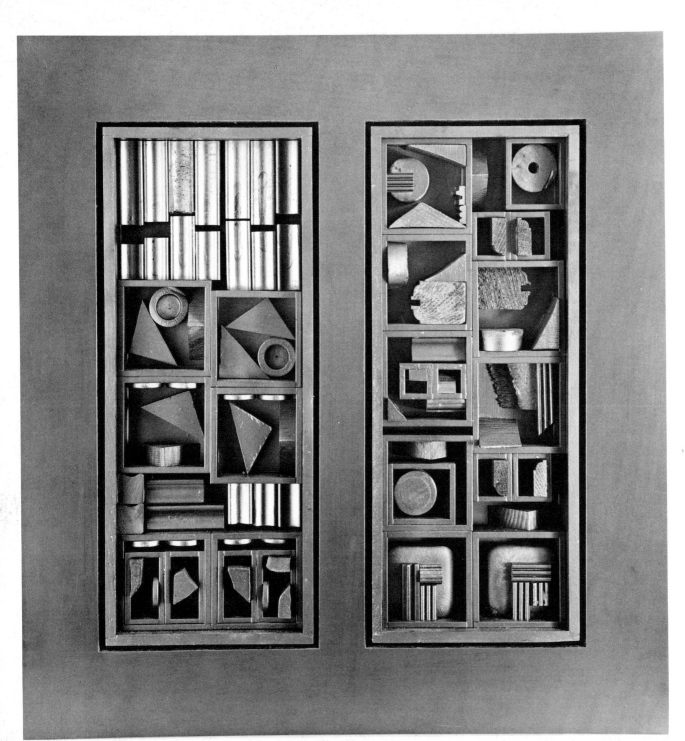

46 BLACK EXCURSION IX 1969 cat no 46 detail at right
Collection Dr. and Mrs. S. Elliot Harris, Pikesville, Maryland

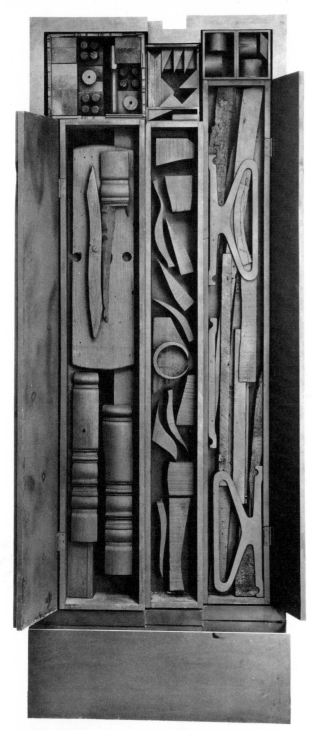

47 NIGHT PERSONAGE PRESENCE 1968 cat no 44
Anonymous loan

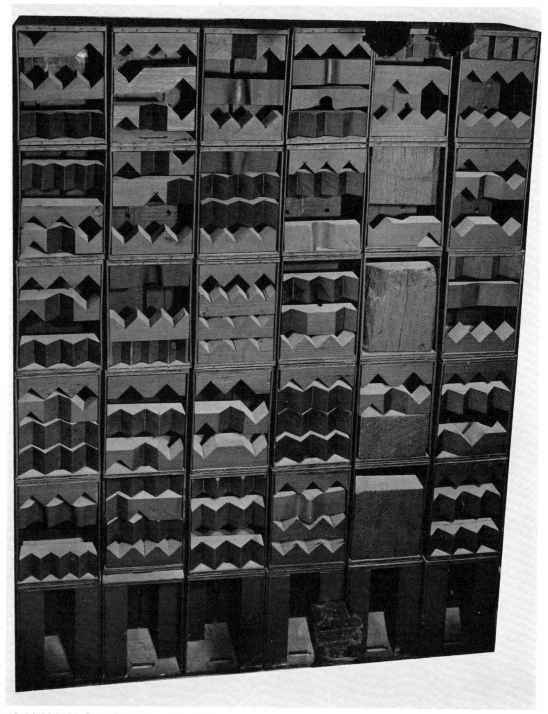

48 LUMINOUS ZAG 1971 cat no 50
Courtesy The Pace Gallery, New York

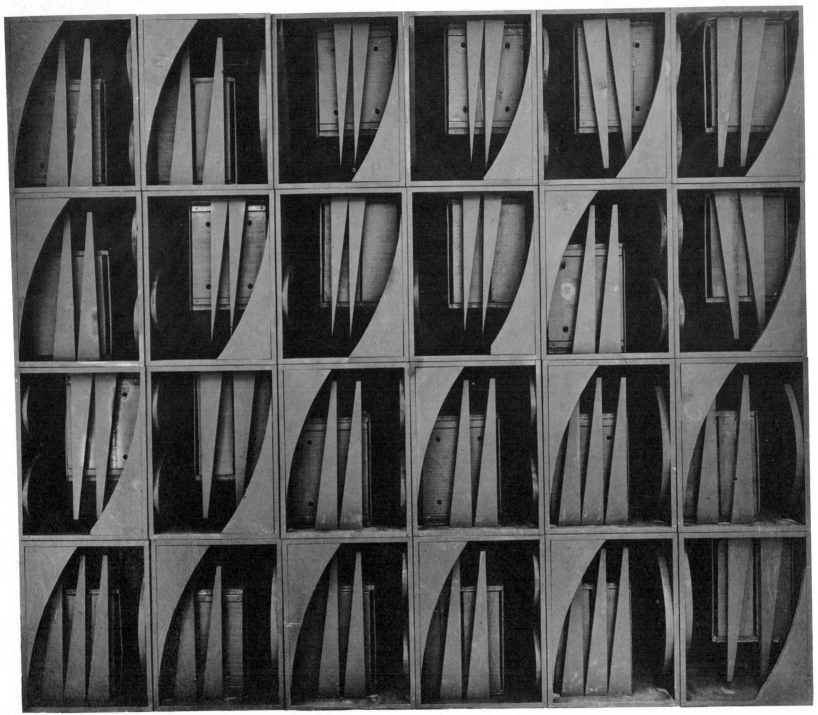

49 NIGHT FOCUS DAWN 1969 cat no 47 detail at right
Collection Whitney Museum of American Art, New York, gift of Howard and Jean Lipman

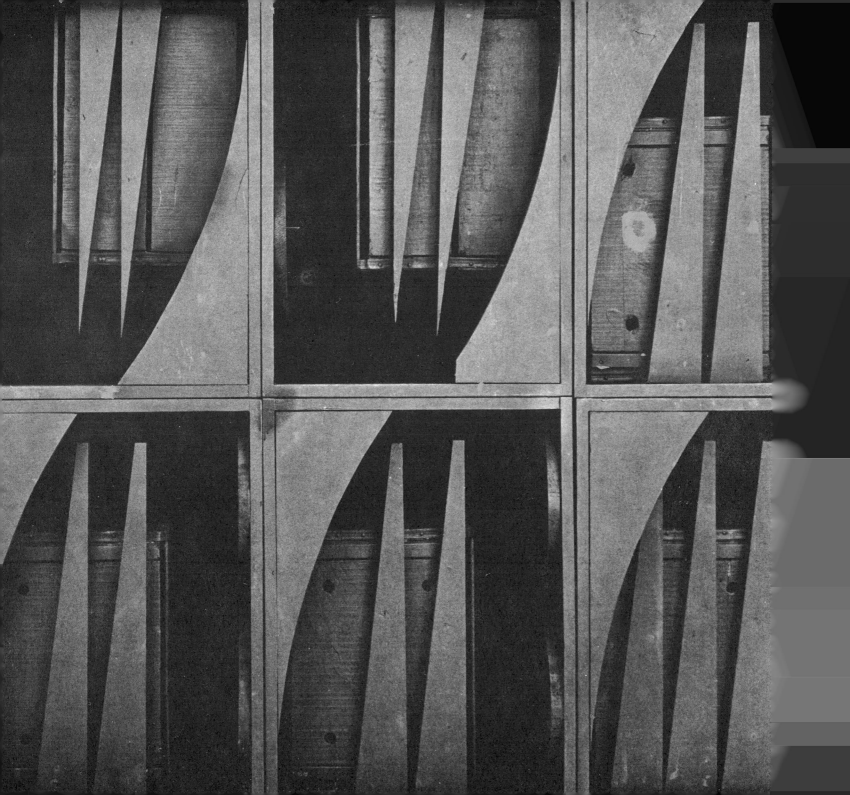

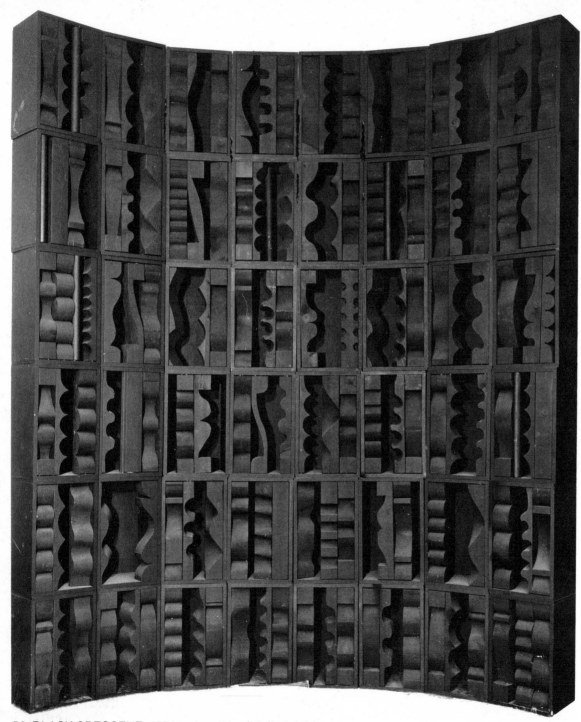

50 BLACK CRESCENT 1971 cat no 51 detail at right
Collection The Metropolitan Museum of Art, gift of Albert and Vera List

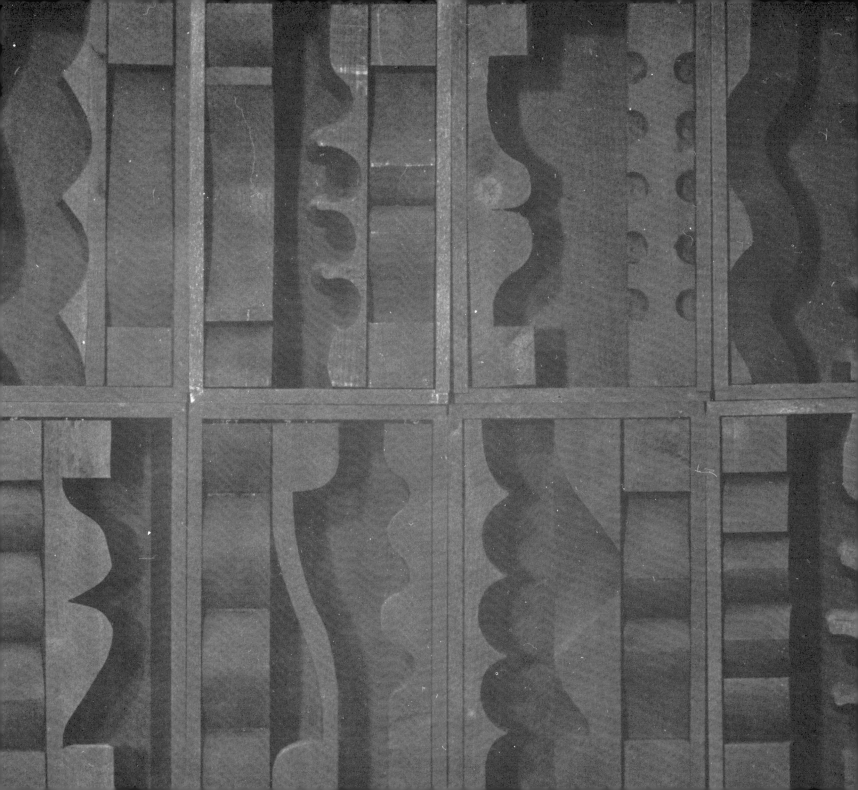

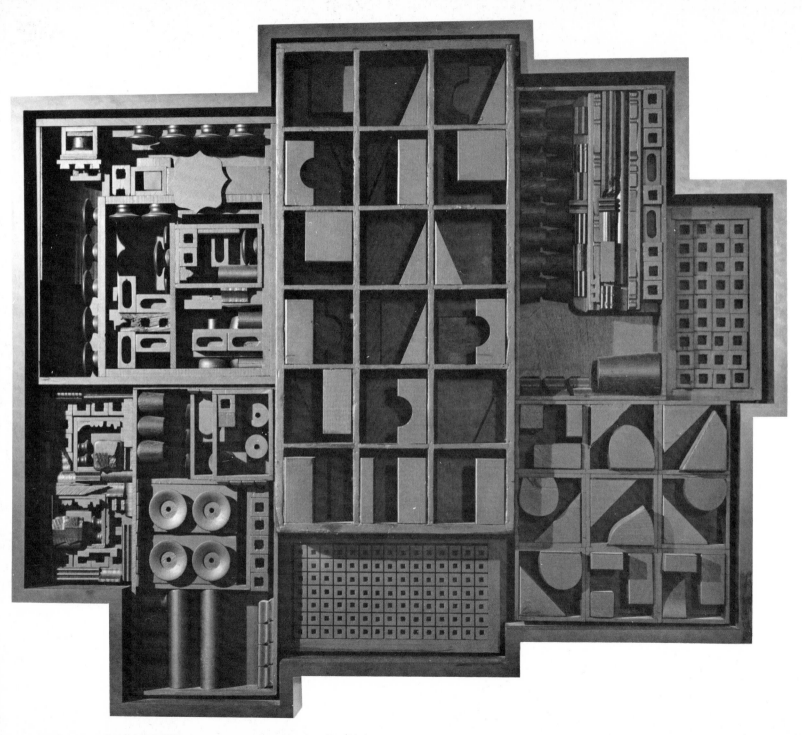

51 HUDSON RIVER SERIES III 1971 cat no 56 detail at right
Collection Mr. and Mrs. Sidney Singer, Jr., Mamaroneck, New York

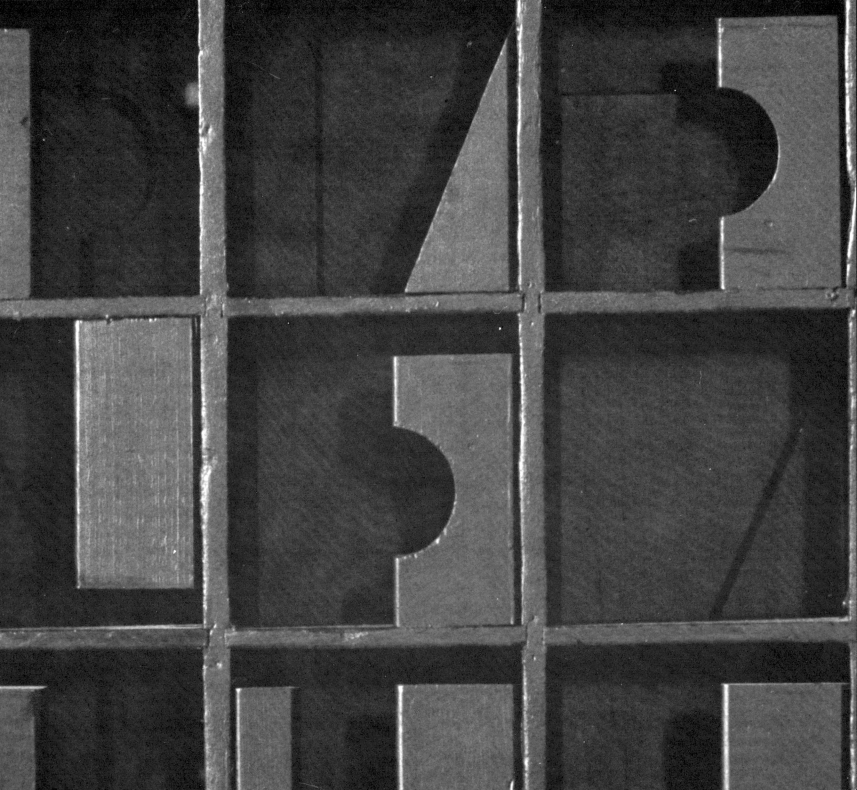

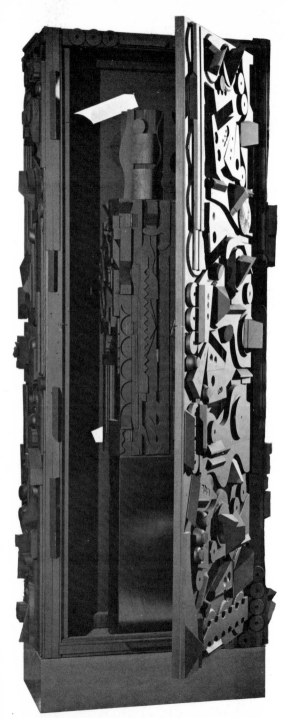

52 DREAM HOUSE XXXV 1972 cat no 69
Collection Mr. and Mrs. Sidney Singer, Jr.,
Mamaroneck, New York

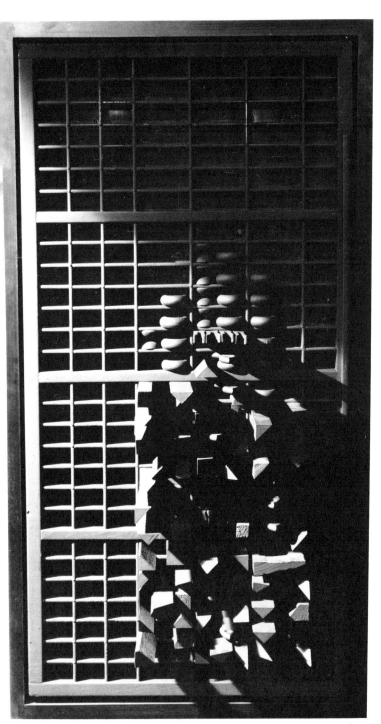

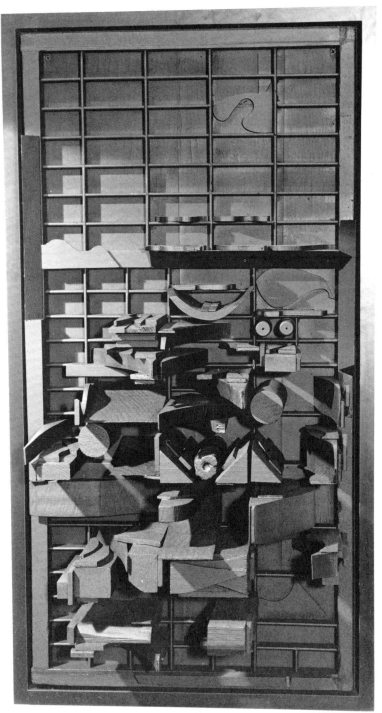

53 END OF DAY III 1972 cat no 72
Collection Mr. and Mrs. Douglas Auchincloss, New York

54 END OF DAY XXX 1972 cat no 77
Collection Mr. and Mrs. Paul M. Ingersoll,
Bryn Mawr, Pennsylvania

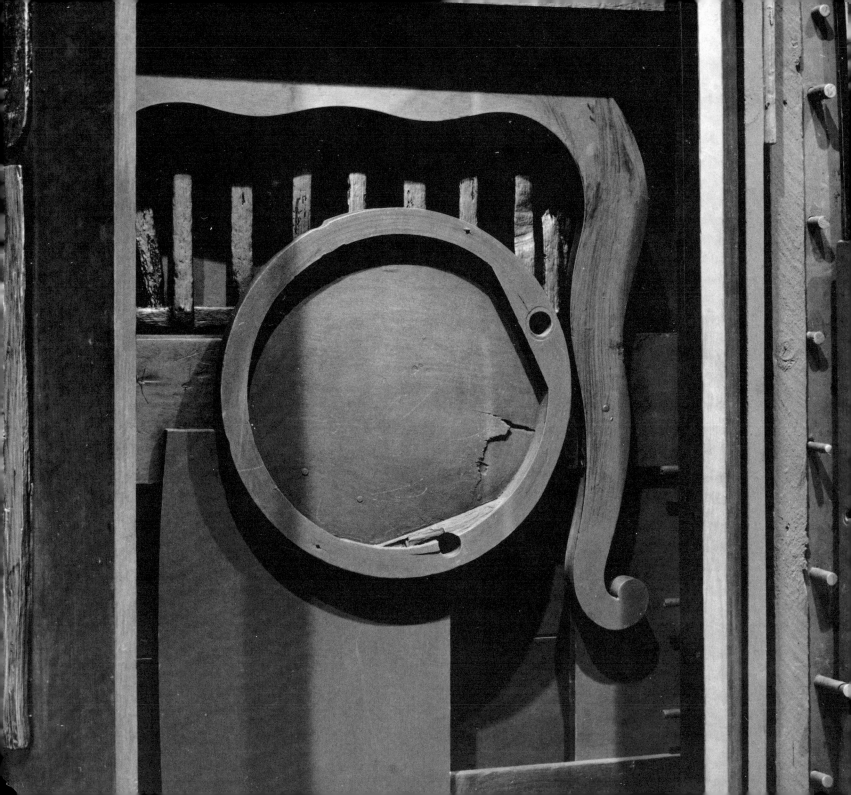

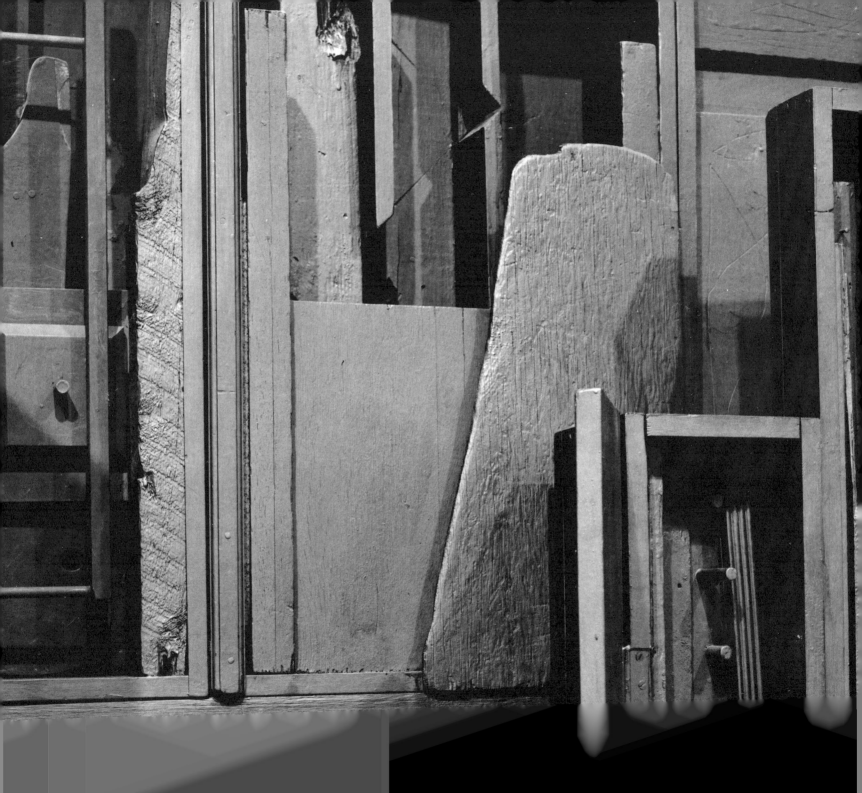

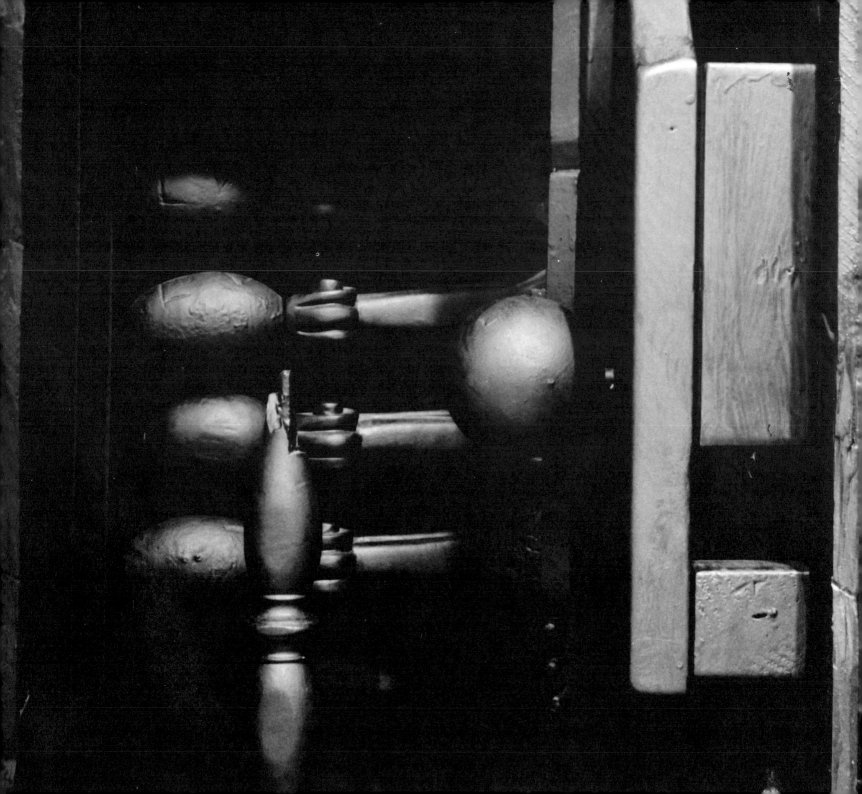

Catalogue of the Exhibition

Unless otherwise noted, all works are wood, painted black. All dimensions are in inches; height precedes width precedes depth. For illustrated works see figure numbers (italics) and page numbers following catalogue entries.

Sculptures

1 EXOTIC LANDSCAPE *1*, p 10
1942-45 12 x 27 x 11 1/4
Courtesy The Pace Gallery, New York

2 MODEL FOR NIGHT PRESENCE IV *27*, p 36
1945 28 x 20 1/2 x 10 1/2
Courtesy The Pace Gallery, New York

3 NIGHT PRESENCE VI *29*, p 37
1955 11 x 33 x 8 1/2
Collection Mrs. Vivian Merrin, New York

4 INDIAN CHIEF *15*, p 25
1955 47 x 26 1/2 x 9
Courtesy Martha Jackson Gallery, Inc., New York

5 NIGHT MUSIC *28*, p 37
1956 13 1/2 x 13 x 15 1/2
Courtesy Martha Jackson Gallery, Inc., New York

6 RELIEF *9*, p 19
1956 35 x 24 x 6
Collection Walker Art Center, gift of the artist

7 UNDERMARINE SCAPE *3*, p 13
1956 wood, painted black; glass; metal
28 1/2 x 17 1/2 x 17
Collection Mr. and Mrs. Ben Mildwoff, New York

8 FIRST PERSONAGE *16*, p 25
1956 front section: 94 x 37 x 11 1/4;
back section: 74 x 24 1/4 x 7 1/4
Collection The Brooklyn Museum, New York,
gift of Mr. and Mrs. Nathan Berliawsky

9 BLACK MIRROR II
1957 72 x 9 x 6
Courtesy Martha Jackson Gallery, Inc., New York

10 QUEEN ANNE *30*, p 38
1957 45 x 21 x 23
Courtesy Martha Jackson Gallery, Inc., New York

11 THE BRIDGE
1957 wood, painted black; velvet 5 x 96 x 5
Collection Arnold and Milly Glimcher, New York

12 MOONSCAPE I
1957-58 84 1/2 x 50 x 6
Courtesy Martha Jackson Gallery, Inc., New York

13 TROPICAL GARDEN I *31*, p 39
1957-59 110 1/2 x 131 1/2 x 12 1/2
New York University Art Collection

14 BOX NO. 1 *4*, p 14
1958 22 x 24 1/2 x 4
Courtesy Martha Jackson Gallery, Inc., New York

15 MOON PERSONAGE II
1959 87 x 8 1/2 x 4 1/2
Courtesy Martha Jackson Gallery, Inc., New York

16 BLACK NIGHTSCAPE
1959 84 x 53 1/2 x 7
Collection Mr. and Mrs. M. A. Lipschultz, Chicago

17 DAWN CATHEDRAL RELIEF
1956-58 wood, painted white 68 1/2 x 41 1/2 x 4
Courtesy Martha Jackson Gallery, Inc., New York

18 DAWN'S WEDDING CHAPEL I *32*, p 40
1959 wood, painted white 90 x 51 x 6
Collection Dr. John W. Horton, Houston

19 DAWN'S WEDDING PILLOW *2*, p 12
1959 wood, painted white 6 1/2 x 36 x 13
Collection Dr. John W. Horton, Houston

20 DAWN COLUMN I *33*, p 42
1959 wood, painted white 102 x 10 1/2 x 10
Courtesy Martha Jackson Gallery, Inc., New York

21 DAWN COLUMN II *34*, p 42
1959 wood, painted white 111 x 16 x 16
Courtesy Martha Jackson Gallery, Inc., New York

22 TOTEM II *36*, p 43
1959 wood, painted white 110 1/2 x 13 1/2 x 14
Courtesy Martha Jackson Gallery, Inc., New York

23 CASE WITH FIVE BALUSTERS *5*, p 16
1959 wood, painted white 28 x 63 1/2 x 8
Courtesy Martha Jackson Gallery, Inc., New York

69 DREAM HOUSE XXXV *52,* p 62
 1972 70 1/2 x 29 x 15
 Collection Mr. and Mrs. Sidney Singer, Jr.,
 Mamaroneck, New York

70 DREAM HOUSE XXXVIII
 1973 80 3/4 x 25 3/4 x 26
 Courtesy The Pace Gallery, New York

71 DREAM HOUSE XXXIX
 1973 86 1/4 x 25 3/4 x 16 1/2
 Courtesy The Pace Gallery, New York

72 END OF DAY III *53,* p 63
 1972 34 1/4 x 18 5/8 x 1
 Collection Mr. and Mrs. Douglas Auchincloss,
 New York

73 END OF DAY V
 1972 34 1/2 x 18 5/8 x 1
 Collection Mr. and Mrs. H. Gates Lloyd,
 Haverford, Pennsylvania

74 END OF DAY VIII
 1972 34 1/4 x 18 5/8 x 1
 Collection S. R. Beckerman, New York

75 END OF DAY X *13,* p 24
 1972 34 1/4 x 18 5/8 x 1
 Collection Dr. Barbaralee Diamonstein, New York

76 END OF DAY XI *14,* p 24
 1972 34 1/4 x 18 5/8 x 1
 Collection Mr. and Mrs. Donn Golden,
 Larchmont, New York

77 END OF DAY XXX *54,* p 63
 1972 34 1/2 x 18 3/4 x 10
 Collection Mr. and Mrs. Paul M. Ingersoll,
 Bryn Mawr, Pennsylvania

78 END OF DAY NIGHTSCAPE II
 1973 65 1/4 x 58 x 3
 Courtesy The Pace Gallery, New York

79 END OF DAY NIGHTSCAPE IV
 1973 95 x 167 x 7
 Courtesy The Pace Gallery, New York

80 NIGHT GARDEN
 1973 10 x 48 x 48
 Courtesy The Pace Gallery, New York

81 BRIDGE PIECE
 1973 40 x 44 x 19 (without base)
 Courtesy The Pace Gallery, New York

Collages

82 Nine untitled collages
 1972 paper each approx. 27 x 37
 A through H: Joseph H. Hirshhorn Collection,
 New York; I: Collection Mrs. Joseph H. Hirshhorn,
 New York

Biography and Bibliography

by Gwen Lerner

1899 Born in Kiev, Russia.

1902-05 Emigrated with family to Rockland, Maine, where her father, Isaac Berliawsky, established a lumber business.

1918 Graduated, Rockland High School.

1920 Married Charles Nevelson, moved to New York and studied visual and performing arts.

1922 Son Myron born.

1928 Enrolled at Art Students League.

1931 Lived independently and traveled alone to Europe, studying at Hans Hofmann's school in Munich and performing minor film roles in Vienna. Traveled through Italy and Paris and returned to New York.

1931-32 Resumed drama instruction and classes at Art Students League, studying there with Hofmann after a second brief trip to Paris. Painted murals as assistant to Diego Rivera and studied dance.

1933 Left Art Students League.

1933-36 Participated in numerous New York group shows.

1937 Joined Works Progress Administration as teacher for the Educational Alliance School of Art.

1941 Began seven year affiliation, Nierendorf Gallery, New York, with her first one-woman exhibition.

1943 Moved to house on 30th Street with garden studio and barn where black painted wood chunks, spoons and found objects were combined in assemblages called the "Farm."

1944 Exhibited abstract wood assemblages at Nierendorf Gallery.

1947 Studied etching briefly with Stanley William Hayter at Atelier 17.

1948 Nierendorf's death. Traveled to Europe.

1949-50 Worked at Sculpture Center in marble and terra-cotta; made unmolded clay cut-outs incised with textures and lines and combined in totemic *Game Figures.*

1950 Traveled twice to Mexico.

1952 Four O'Clock Forum Sunday panel discussions at Nevelson's house.

1953 Met Colette Roberts, director of the non-profit Grand Central Moderns Gallery, New York. Worked again at Atelier 17.

1955 Began three-year affiliation with Grand Central Moderns Gallery.

1956 Whitney Museum of American Art acquired BLACK MAJESTY, gift of Mr. and Mrs. Ben Mildwoff through the Federation of Modern American Painters and Sculptors.

1957 Began enclosing reliefs in shadow boxes. Created first wall. The Brooklyn Museum acquired FIRST PERSONAGE, gift of Mr. and Mrs. Nathan Berliawsky.

1957-59 President, New York Chapter of Artists Equity.

1958 The Museum of Modern Art acquired SKY CATHEDRAL, gift of Mr. and Mrs. Ben Mildwoff.

1959 First major museum exhibition: *Sixteen Americans,* The Museum of Modern Art, New York. Moved to 29 Spring Street. Began four year affiliation with Martha Jackson Gallery, Inc., New York.

1962 Selected by The Museum of Modern Art to represent the United States with Jan Muller, Loren MacIver and Dimitri Hadzi at the XXXI Biennale Internazionale d'Arte, Venice. Began affiliation with Sidney Janis Gallery, New York. First woman and first American sculptor represented by the gallery. First Vice-President, Federation of Modern Painters and Sculptors.

1963 Ended affiliation with Janis Gallery. Fellowship to Tamarind Lithography Workshop, Los Angeles. President, National Artists' Equity.

1964 Began affiliation with The Pace Gallery, New York.

1965 Participated in National Council on Arts and Government in Washington. President, National Artists Equity.

1966 Vice-President, International Association of Artists. Head of Advisory Council on Art of the National Historic Site Foundation, Inc.

1967 First major retrospective exhibition, Whitney Museum of American Art, New York.

1969 Commissioned by Princeton University to do her first monumental cor-ten steel sculpture.

One Woman Exhibitions

Catalogues and brief reviews are cited with the exhibitions. Longer articles on these exhibitions are listed by author's name under Periodicals.

1941 Nierendorf Gallery, New York. ("Louise Nevelson's Debut," *Art Digest,* 1 October 1941, p 7)

1942 Nierendorf Gallery, New York. ("Louise Nevelson, Sculptor," *Art Digest,* 15 October 1942, p 18)

1943 Norlyst Gallery, New York, *The Circus; The Clown is the Center of His World; The Crowd Outside.* (Maude Riley, "Irrepressible Nevelson," *Art Digest,* 15 April 1943, p 18)

Nierendorf Gallery, New York, *Drawings* (see above, Riley, *Art Digest,* April 1943)

Nierendorf Gallery, New York, *A Sculptor's Portraits in Paint.* (Maude Riley, "57th Street in Review," 15 November 1943, p 19)

1946 Nierendorf Gallery, New York, *Ancient City*

1950 Lotte Jacobi Gallery, New York, *Moonscapes*

1954 Lotte Jacobi Gallery, New York. (S. G., "57th Street: Louise Nevelson," *Art Digest,* January 1954, p 16)

Marcia Clapp Gallery, New York. (B. G., "Reviews and Previews," *Art News,* May 1954, p 43)

1955 Grand Central Moderns Gallery, New York, *Ancient Games and Ancient Places.* (S. B., "Nevelson," *Arts Digest,* 1 January 1955, p 21)

1956 Grand Central Moderns Gallery, New York, *The Royal Voyage.* (P. T., "Reviews and Previews," *Art News,* February 1956, p 48)

1957 Grand Central Moderns Gallery, New York, *The Forest.* (F. P., "Reviews and Previews," *Art News,* January 1957, p 23)

1958 Grand Central Moderns Gallery, New York, *Moon Garden Plus One.* (P. T., "Reviews and Previews," *Art News,* January 1958, p 54; C. B., "In the Galleries," *Arts,* January 1958, p 55)

Esther Stuttman Gallery, New York. (H. D. H., "Reviews and Previews," *Art News*, March 1958, p 13; A. V., "In the Galleries," *Arts*, March 1958, p 58)

1959 Martha Jackson Gallery, Inc., New York, *Sky-Columns-Presence*. (J. S., "Reviews and Previews," *Art News*, December 1959, p 19; M. S., "In the Galleries," *Arts*, December 1959, p 57)

1960 David Herbert Gallery, New York. Pamphlet: reviews, biography, checklist, illus. (V. R., "Reviews and Previews," *Art News*, January 1960, p 13; J. R. M., "In the Galleries," *Arts*, February 1960, p 61)

Devorah Sherman Gallery, Chicago. Pamphlet: review, biography, checklist, illus.

Galerie Daniel Cordier, Paris, *Exposition de Louise Nevelson Sculpteur*. (Francoise Choay, "Paris," *Arts*, January 1961, p 17; J. Y. Mock, "Louise Nevelson at the Galerie Daniel Cordier," *Apollo*, December 1960, p 207)

1961 Martha Jackson Gallery, Inc., New York, *Nevelson*. Catalogue: Foreword by Kenneth Sawyer; poem by Jean Arp; commentary by Georges Mathieu; checklist, biography, illus. (J. K., "Reviews and Previews," *Art News*, May 1961, p 10)

Staatliche Kunsthalle, Baden-Baden. Organized by U.S.I.S. and The Museum of Modern Art, New York

The Pace Gallery, Boston

1962 Martha Jackson Gallery, Inc., New York. (I. H. S., "Reviews and Previews," *Art News*, March 1962, p 15)

1963 Sidney Janis Gallery, New York, *Night Gardens, New Continents, Dawns*. (J. K., "Reviews and Previews," *Art News*, February 1963, p 15; Michael Fried, "New York Letter," *Art International*, February 1963, pp 62-63)

Hanover Gallery, London, *Louise Nevelson: First London Exhibition*. Catalogue: biography, checklist, illus. (G. S. Whittet, *Studio International*, January 1964, p 32, illus.)

Balin-Traube Gallery, New York. (R. C., "Reviews and Previews," *Art News*, December 1963, p 14)

Martha Jackson Gallery, Inc., New York. (L. C., "Reviews and Previews," *Art News*, September 1963, p 12)

1964 The Pace Gallery, New York and Boston. (K. L., "Reviews and Previews," *Art News*, January 1965, p 14)

Gimpel-Hanover Gallery. Zurich. (*Werk*, March 1964, sup 59. illus.)

Kunsthalle, Bern. (P. F., *Werk*, July 1964, sup 157)

Galeria d'Arte Contemporanea, Turin

1965 David Mirvish Gallery, Toronto

Galerie Schmela, Dusseldorf

1966 The Pace Gallery, New York. (H. R., "Reviews and Previews." *Art News*, Summer 1966, p 13)

Ferus-Pace Gallery, Los Angeles

Harcus/Krakow Gallery, Boston, *Nevelson: Prints and Sculptures*

1967 Whitney Museum of American Art, New York, *Louise Nevelson*. Catalogue: John Gordon, Praeger Publishers, Inc.; essay, checklist, biography, exhibitions, bibliography, illus. (J. S., "In the Museums," *Arts*, April 1967, p 55)

The Pace Gallery. New York. (M. S. Young. *Apollo*, July 1967, p 66)

Galerie Daniel Gervis, Paris. (J. Alvard, "Paris," *Art News*, September 1967., p 63)

Rose Art Museum, Brandeis University, Waltham, Massachusetts

1968 Dunkelman Gallery, Toronto. (G. M. Dault, "Louise Nevelson at Dunkelman," *Arts Canada*, December 1968, p 87, illus.)

Arts Club of Chicago. *Louise Nevelson*. Catalogue: checklist, statements, biography. illus.

The Pace Gallery, New York. (R. N., "In the Galleries," *Arts*, February 1968, p 58; E. C. B., "Reviews and Previews," *Art News*, March 1968, p 22)

1969 The Pace Gallery, New York, *Nevelson: Recent Wood Sculpture*. Catalogue: photograph-checklist, biography, exhibitions. bibliography.

The Pace Gallery. Columbus, Ohio

Galeria Civica de Arte Moderno, Turin, *Louise Nevelson, Sculpture-Lithographs*. Catalogue: Foreword by Luigi Malle; checklist.

Akron Art Institute, Ohio, *Recent Wood Sculpture, Louise Nevelson*. Catalogue: Foreword by Ann Unal; checklist, illus.

Rijksmuseum Kroller-Muller, Otterlo. The Netherlands, *Louise Nevelson, Sculptures 1959-1969*. Catalogue: Introduction by R. Oxenaar; biography, checklist, exhibitions, bibliography, illus.

Galerie Jeanne Bucher, Paris, *Louise Nevelson*. Catalogue: introduction, biography, photograph-checklist.

Harcus/Krakow Gallery, Boston

Martha Jackson Gallery, Inc., New York. (M. L., "Reviews and Previews," *Art News*, December 1969, p 18; A., "In the Galleries," *Arts*, December 1969, p 65)

1969-70 The Museum of Fine Arts, Houston, *Louise Nevelson*. Catalogue: Introduction by Mary Hancock Buxton; biography, collections, checklist, poetry, illus. Also shown at University of Texas, College of Fine Arts, Austin.

1970 Whitney Museum of American Art, New York. (M. W., "Louise Nevelson at the Whitney Museum," *Arts*, December 1970, p 51; Gerrit Henry, "New York Letter," *Art International*, January 1971, p 39)

The Pace Gallery, New York. (J. S., "Reviews and Previews," *Art News*, December 1970, p 58)

1971 Makler Gallery, Philadelphia

Pace Graphics, New York. (K. L., "Reviews and Previews," *Art News*, May 1971, p 60)

The Pace Gallery, New York, *Seventh Decade Garden*. (A., "Louise Nevelson at Pace," *Arts*, Summer 1971, p 49; W. Domingo, "In the Galleries," *Arts*, September 1971, p 59; H. Raymond, "New York," *Art and Artists*, August 1971, p 54; J. S., "Reviews and Previews," *Art News*, September 1971, p 16)

1971-72 Richard Gray Gallery, Chicago, *Nevelson, Works of 1959-1963*

1972 Dunkelman Gallery, Toronto

Parker 470, Boston, *Seventh Decade Garden*

Pace Editions, New York

The Pace Gallery, New York. (April Kingsley, "Reviews," *Artforum,* February 1973, pp 87-88; Lawrence Campbell, "Reviews and Previews," *Art News,* December 1972, p 11; Ellen Lubell, "Gallery Review," *Arts,* December 1972, p 83)

1973 Pace Editions, New York

Studio Marconi, Milan, *Nevelson.* Catalogue: "Louise Nevelson, Una Storia Americana," by Franco Russoli; excerpts from Arnold Glimcher, *Louise Nevelson* (see Books); checklist, biography, exhibitions, illus. Text in Italian. Also shown at Moderna Museet, Stockholm.

Selected Group Exhibitions

Catalogues are listed with the exhibitions

1934 Secession Gallery, New York

1935 The Brooklyn Museum, New York, *Young Sculptors*

1936 A.C.A. Gallery, New York. Honorable mention awarded by judges Yasuo Kuniyoshi, Stuart Davis, Max Weber

1941 The Museum of Modern Art, New York, *Art in Therapy.* Prize
Art of This Century, New York

1944 Nierendorf Gallery, New York, *Sculpture Montages*

The Pennsylvania Academy of Fine Arts, Philadelphia, *139th Annual Exhibition*

1948-49 Artists Gallery and The Sculpture Center, New York

1953 Grand Central Moderns Gallery, New York. Selected by Hugo Robus and Milton Hebald

1955-56 Stable Gallery, New York

1958 Whitney Museum of American Art, *Nature in Abstraction.* Catalogue: By John I. H. Baur, The Macmillan Co., New York, p 76, illus.

American Federation of Arts, New York, *Art and the Found Object*

Galerie Jeanne Bucher, Paris

1959 The Museum of Modern Art, New York, *Sixteen Americans.* Catalogue: Edited by Dorothy C. Miller, pp 52-57, illus.

New York Coliseum, *Art, U.S.A.* Grand Prize, Sculpture

1960 Art Institute of Chicago, *63rd American Exhibition.* Logan Award

Martha Jackson Gallery, Inc., New York, *New Media and New Forms I and II*

Munson-Williams-Proctor Institute, Utica, *Art Across America*

1961 The Museum of Modern Art, New York, *The Art of Assemblage.* Catalogue: By William C. Seitz, pp 72, 118, illus.

Tanager Gallery, New York, *The Private Myth*

Hanover Gallery, London

1962 Venice, *XXXI Biennale Internazionale d'Arte* (United States Pavilion). Catalogue: *2 Pittori 2 Scultori.* By William C. Seitz, pp 5-10, illus. Text in Italian and English. Exhibition organized by The International Council of The Museum of Modern Art. Also: *Ente Autonomo "La Biennale di Venezia."* Essay, "Stati Uniti d'America" by Rene d'Harnoncourt, checklist. pp 221-224.

World's Fair, Seattle, *Art Since 1950*

1964 Kassel, West Germany, *Documenta III.* Catalogue: *Malerei, Skulptur,* Verlag M. DuMont Shauberg, Koln, pp 272-273, illus.

The Tate Gallery, London, *Painting and Sculpture of a Decade, 54-64.* Catalogue: Organized by Alan Bowness, Lawrence Gowing and Philip James for the Calouste Gulbenkian Foundation. pp 84-85, illus.

1965 Musee Rodin, Paris, *American Sculpture of the 20th Century*

Dallas Museum of Fine Arts, *Sculpture 20th Century*

1966 The Museum of Modern Art, New York, *Contemporary Painters and Sculptors as Printmakers*

Art Institute of Chicago, *68th American Exhibition*

1967 Art Institute of Chicago, *Sculpture: A Generation of Innovation*

Los Angeles County Museum of Art, *American Sculpture of the '60's.* Catalogue: Edited and introduction by Maurice Tuchman, pp 57, 163, 250, illus.

The Solomon R. Guggenheim Museum, New York, *Guggenheim International*

Kassel, West Germany, *Documenta IV.* Catalogue: *4 Documenta,* Verlag: Druck and Verlag GmbH. Kassel, pp 96-99, illus.

1969 The Museum of Modern Art, New York, *Tamarind: Homage to Lithography*

1970 Princeton University Art Museum, *American Art Since 1960*

Osaka, Japan, *Expo 70*

*Nevelson works temporarily reconstructed from Galerie Daniel Cordier circulating exhibition, 1971.

Annuals

Carnegie Institute, *Pittsburgh International Exhibition:* 1958, 1961, 1964, 1970
Whitney Museum of American Art Annual: 1946, 1947, 1950, 1953, 1956, 1957, 1958, 1960, 1962, 1964, 1966, 1969
National Association of Women Artists: 1952, 1955, 1957, 1959, 1960

Books

The Brooklyn Museum. *Louise Nevelson: Prints and Drawings 1953-1966.* New York: Shorewood Publications, Inc., 1967. Introduction by Una E. Johnson, checklist, biography, bibliography, illus.

Glimcher, Arnold B. *Louise Nevelson.* New York: Praeger Publishers, Inc., 1972. Most definitive biography and analysis of Nevelson to date. Biographical summary, major exhibitions and collections, prologue by the artist, photograph-checklist of selected works 1930-1972, fully illustrated, including 12 color plates

Janis, Harriet and Blesh, Rudi. *Collage: Personalities, Concepts, Techniques.* Philadelphia: Chilton Co., 1962. Brief references to Nevelson, accompanied by four illustrations

Roberts, Colette. *Nevelson.* Paris: The Pocket Museum, Editions Georges Fall, 1964. Three essays: "Timelessness and Timeliness of Nevelson," "A World of Forms, Nevelson's 'elsewhere,'" "From Spring Street to Venice and the Biennale." Biographical landmarks with exhibitions and review references, major collections, fully illustrated, including four color plates

Periodicals

Andreae, Christopher. "Nevelson's Little Boxes — or Are They Big?." *Christian Science Monitor,* 1967. (Review, Whitney retrospective exhibition, 1967)

Arp, Jean. "Louise Nevelson," *XXe Siecle,* June 1960. Sup (19), illus.

Ashton, Dore. "Art," *Arts and Architecture*, June 1961, pp 4-5, illus.

——————. "Art U.S.A. 1962," *Studio International*, March 1962, p 94, illus.

——————. "Art: Worlds of Fantasy," *The New York Times*, 29 October 1959, illus. (Review, *Sky-Columns-Presence*)

——————. "Exhibition at the Janis Gallery," *Das Kunstwerk*, April 1963, p 31, illus.

——————. "La Sculpture Americaine," *XXe Siecle*, December 1960, p 87, illus.

——————. "New York Commentary," *Studio International*, July 1966, p 45, illus. (Review, Pace exhibition, 1966)

——————. "New York Commentary," *Studio International*, June 1969, pp 287-289, illus. (Review, Pace exhibition, 1969)

——————. "U.S.A.: Louise Nevelson," *Cimaise*, April-June 1960, pp 26-36, illus.

Blok, C. "Letter from Holland," *Art International*, November 1969, p 52, illus. (Review, Kroller-Muller exhibition)

Bongartz, Roy. " 'I Don't Want to Waste Time,' Says Louise Nevelson at 70," *The New York Times Magazine*, 24 January 1971, pp 12-13, 30-33, illus.

Budnick, Dan. "Louise Nevelson with Cathedral One," *Vogue*, 1 August 1962, illus.

Canaday, John. "Art: How to Miss a Boat and Catch a Toboggan," *The New York Times*, 16 May 1971, illus. (Review, *Seventh Decade Garden*)

——————. "Art: Ingenuity of Louise Nevelson," *The New York Times*, 4 November 1972, illus. (Review, Pace exhibition, 1972)

——————. "Art: Louise Nevelson and the Rule Book," *The New York Times*, 6 April 1969, p D25, illus. (Review, Pace exhibition, 1969)

——————. "Whither Art?," *The New York Times*, 26 March 1961, illus. (Review, panel discussion, Philadelphia Museum College of Art)

Coates, Robert M. "The Art Galleries: Louise Nevelson," *The New Yorker*, December 5 1964, pp 160-162

Danieli, Fidel. Ferus/Pace Gallery Opening, *Artforum*, February 1967, p 63, illus.

Devree, Howard. "About the Art and Artists," *The New York Times*, 22 April 1954. (Review, Clapp exhibition)

——————. *The New York Times*, 28 September 1941. (Review, Nierendorf exhibition, 1941)

de Gallotti, Marianna Minoia. "Exposicion Louise Nevelson," *Goya*, May-June 1969, p 413, illus. Text in Italian. (Review, Turin exhibition, 1969)

Genauer, Emily. *New York Herald Tribune*, 12 January 1958. (Review, *Moon Garden Plus One*)

——————. "Rouault as Mirror and Prophet," *New York Herald Tribune*, 22 November 1964, p 37, illus.

Gent, George. "Nevelson Thanks the City in Steel," *The New York Times*, 15 December 1972, illus.

Glimcher, Arnold. "Nevelson: How She Lives, Works, Thinks," *Art News*, November 1972, pp 69-73, illus.

Goya, July-August 1969, p 33, illus., "Esculturas Inquietantes." Text in Italian. (Review, Bucher exhibition, 1969)

Gruen, John, "Art in New York, Silent Emanations," *New York Magazine*, 14 April 1969

Hess, Thomas B. "U.S. Art, Notes from 1960," *Art News*, January 1960, pp 24-29, illus.

Kozloff, Max. "Art," *The Nation*, 10 April 1967, pp 477-478 (Review, Whitney retrospective exhibition, 1967)

Kramer, Hilton. "Art," *The Nation*, 26 January 1963, pp 78-79 (Review, Janis exhibition)

——————. "Month in Review," *Arts*, January 1957, pp 44-47, illus. (Review, *The Forest*)

——————. "The Sculpture of Louise Nevelson," *Arts*, June 1958, pp 26-29, illus.

——————. "A Triumph of Constructivism," *The New York Times*, 28 January 1968 (Review, Pace exhibition, 1968)

Lanes, Jerrold. "New York," *Artforum*, February 1970, p 74, illus. (Review, Martha Jackson exhibition, 1969)

Lipman, Howard W. "Sculpture Today," *Whitney Review*, 1961-62. (Statement by artist)

Mazer, G., ed., "Lifestyle," *Harper's Bazaar*, April 1972, pp 112-113

Mellow, James R. "Nevelson: More Surprises Ahead?," *The New York Times*, 6 December 1970, illus. (Review, Whitney exhibition, 1970)

——————. "Nevelson's Night Music Plays On," *The New York Times*, 19 November 1972 (Review, Pace exhibition, 1972)

——————. "New York Letter," *Art International*, Summer 1969, p 48 (Review, Pace exhibition, 1969)

——————. "Sculpture Swings to an Industrial Look," *Industrial Design*, March 1967, p 62, illus.

Melville, Robert. "Exhibitions: The Venice Biennale," *Architectural Review*, October 1962, pp 285-286, illus.

Nevelson, Louise. "Art at the Flatbush Boys' Club," *Flatbush Magazine*, June 1935, p 3

——————. "Do Your Work," *Art News*, January 1971, p 41, illus.

——————. *Metropolitan Museum of Art Bulletin*, November 1967, pp 132-133, illus.

——————. "Nevelson on Nevelson," *Art News*, November 1972, pp 66-68, illus.

Newsweek, 9 November 1959, p 119, "Art: Adventurous Sculptress"

Newsweek, 4 December 1972, p 116, "Art: Gothic Queen"

Picard, Lil. "Tausend und einige Holzer: Besuch Bei Louise Nevelson," *Das Kunstwerk*, September 1961, pp 15-24, illus. Text in German. (Review, Staatliche Kunsthalle exhibition)

Pincus-Witten, Robert. "Louise Nevelson, Whitney Museum," *Artforum*, May 1967, p 58, illus. (Review, Whitney exhibition, 1967)

Preston, Stuart. *The New York Times*, 16 January 1955. (Review, *Ancient Games and Ancient Places*)

——————. "The Rising Tide of Exhibitions," *The New York Times*, 1 December 1957, (Review, *Moon Garden Plus One*)

Ragon, Michel. "Constructions Oniriques," *XXe Siecle*, December 1969, p 113, illus. (Review, Bucher exhibition, 1969)

Raynor, Vivien. "Louise Nevelson at Pace," *Art in America*, January-February 1973, pp 114-115. (Review, Pace exhibition, 1972)

Rosenblum, Robert. "Louise Nevelson," *Arts Yearbook 3: Paris/New York*, 1959, pp 136-139, illus.

Schwartz, M. D. "Sixteen Americans at The Museum of Modern Art," *Apollo*, February 1960, p 50, illus.

Seckler, Dorothy Gees. "Louise Nevelson," *Art in America*, January-February 1967, pp 32-43, illus.

Seiberling, Dorothy. "Weird Woodwork of Lunar World," *Life*, 24 March 1958, pp 77-80, illus.

Shirley, David L. "She and Her Shadows," *Newsweek*, 20 March 1967, p 110, illus.

Smith, Dido. "Louise Nevelson," *Craft Horizons*, May-June 1967, pp 44-49, 74-79, illus.

Steele, Mike. "Artist Louise Nevelson: Recognition Comes to Free Spirit," *Minneapolis Tribune*, 6 May 1971, pp 1, 6, illus.

The New York Times, 12 March 1967. (Review, Whitney retrospective exhibition)

Tillim, Sidney. "New York Exhibitions: Month in Review," *Arts*, February 1963, pp 40-42, illus. (Review, Janis exhibition)

Time, 3 February 1958, p 58, illus., "One Woman's World"

Time, 31 August 1962, p 40, illus. "All That Glitters"

Time, 31 March 1967, p 86, illus., "Sculpture: Mansions of Mystery"

Microfilms

Smithsonian Institution. Archives of American Art, 5200 Woodward Avenue, Detroit, Michigan 48202 Rolls D-296 through D-296E.

Thousands of documents comprise the Nevelson microfilm records. Largely unedited, they fall into the following general categories:

clippings (miscellaneous)
collections
correspondence (dealers' and personal)
exhibition announcements, catalogues and lists
interviews
inventories and dealers' records
news releases
original essays, poetry and statements by artist
photographs (art works and personal)
reviews

This apparently random collection of microfilm material includes many important items. For example, reviews, photographs and news releases document Nevelson's early works before illustrated catalogues on them were being published. Correspondence from family and friends during that early period provides some insight into her evolution as an artist. Included in this memorabilia are sonnets on *Moon Garden Plus One* by Parker Tyler, poetry and prose by Nevelson's son, Mike, and a statement by Seymour Lipton about his art, sent to Nevelson at her request.

The roughly assembled lists of collections and exhibitions are useful mainly for comparison with several other published lists cited in this bibliography (see books, catalogues). The dealers' records, correspondence and gallery inventories are similarly of secondary interest.

Since the late fifties, the microfilmed material is more thorough and increases in proportion to the growing recognition of her art. Included are personal interviews, references to her exhibitions and talks, reviews, mention of awards and documentation of activities in such professional organizations as the National Artists Equity.

Nevelson's searching attempts at self-definition in interviews, talks and poetry reveal a consistent philosophical direction. She regards making art as an inevitable organic process, a mandate for which she accepts complete responsibility. Consequently, her published and unpublished statements which appear in the microfilm records crackle with self-confidence and a profound sensitivity to life.

Unpublished Taped Interviews

(used in preparation of this catalogue)

Louise Nevelson with Jay Belloli, Assistant Curator, Walker Art Center, Minneapolis, 1971

Louise Nevelson with Dean Swanson, Chief Curator, and Gwen Lerner, Registrar, Walker Art Center, and Richard Solomon, Pace Editions, Inc., New York, 1973

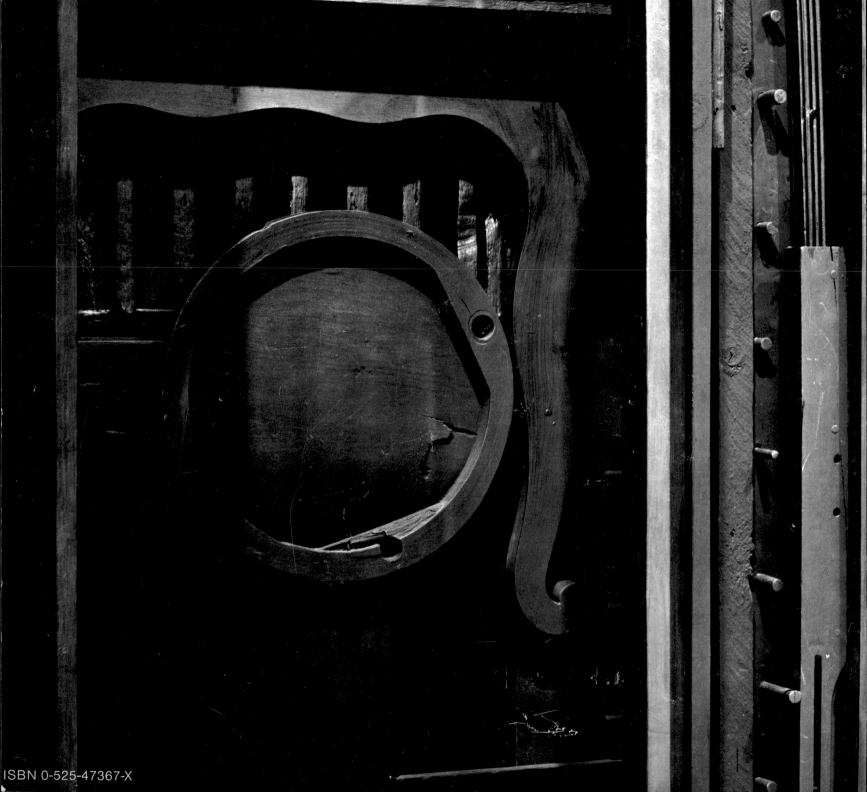

ISBN 0-525-47367-X